GHOSTS OF POCATELLO

GHOSTS OF POCATELLO

HAUNTED HISTORY FROM THE GATE CITY

JOHN BRIAN

Haunted America

Published by Haunted America
A Division of The History Press
Charleston, SC 29403
www.historypress.net

Unless otherwise noted, all photographs taken by Lisa Brian.

First published 2013

Manufactured in the United States

ISBN 978.1.60949.965.5

Library of Congress CIP data applied for.

Notice: The information in this book is true and complete to the best of our knowledge. It is offered without guarantee on the part of the author or The History Press. The author and The History Press disclaim all liability in connection with the use of this book.

Dedicated to the members of SPIRO and the city of Pocatello, our beloved home.

CONTENTS

INTRODUCTION

Ghosts of Pocatello: Haunted History from the Gate City is the product of six years of paranormal investigation by John Brian and SPIRO Paranormal. John was born and raised in Pocatello and has a BA in anthropology and Spanish from Idaho State University. He also attended La Universidad de Guadalajara in Guadalajara, Jalisco, Mexico. John worked in Mexico and Latin America as an anthropologist but returned to Idaho in 2001. John and Lisa Brian are married and have four children: John David, Ellie, Megan and Brisa.

After returning home, John wanted to continue working in anthropology on his own. Paranormal research became an excellent way for him to continue to work in the field. John focused not on the reported hauntings but on the people who were having the experience. From this prospective, SPIRO Paranormal investigates ghostly encounters from a social science viewpoint, making it truly "scientific."

In 2009, Old Town Pocatello, Inc. joined with SPIRO Paranormal to host the Haunted History Tour. The tour has become very successful and is highly anticipated by the community. The event allows the public to enter historic buildings and hear stories of possible paranormal activity. Since SPIRO investigates all of the buildings prior to the tour, actual evidence of paranormal activity is presented at some of the locations. The year 2013 will mark the fifth-annual Haunted History Tour.

Over the five years of presenting the Haunted History Tour, John has recorded many firsthand accounts of paranormal experiences. *Ghosts of*

Pocatello: Haunted History from the Gate City is an attempt to put some of these stories with a historical perspective into the public record. All of the stories included in this book are based on real events and locations. Names have been changed and some stories have been altered but generally follow the facts as told to the writer. Some of the stories are based on the experiences from the members of SPIRO Paranormal and others from the people with whom they have come into contact. It is our intention to record these stories as an oral tradition for the people of Pocatello.

It is my sincere hope you enjoy the stories contained in this book.

HISTORY OF POCATELLO

The city of Pocatello was named after the Native American Shoshoni chief Pocatello, who allowed passage of the railroad through the Fort Hall Indian Reservation. Fort Hall, just north of Pocatello, was established by Nathaniel Jarvis Wyeth and became an important trading post on the Snake River in 1846. The trading post was located at the end of a five-hundred-mile convergence between the Oregon and California trails, serving as the main mercantile throughout the area in the 1850s.

When gold was discovered in 1860, immigrants flocked to Idaho in hopes of striking it rich. Along with the migrants came the railroad lines. Originally called Pocatello Junction, Pocatello's origin was that of a rail stop during the Idaho Gold Rush. It was not until gold rush frenzy diminished that settlers really began arriving in the area to stay. In 1882, commercial and residential expansion emerged in Pocatello, giving birth to the "warehouse district" that would later become an important agricultural and commercial hub for the Northwest.

Pocatello's history began very differently than most of its neighboring towns. Unlike many of the surrounding cities, which trace their lineage to religious roots, Pocatello had a very dark beginning. Ruffians, speak-easies, opium dens, gambling and prostitution were just a few things common in Pocatello's colorful past. The city also maintained an extensive underground tunnel system believed to be used in the transport of money, entering secret gambling speak-easies or simply as escape routes. Some of these tunnels still exist today.

Aboveground, Pocatello's Main Street was the social center of the city, boasting opera houses and theaters such as the Auditorium, the Princess

Theater, the Lyric, the Center Street Orpheum, the Gem & Star, the Crown, the Rex, the Capitol and the Chief Theater. As the population of Pocatello grew, so did the number of opera houses and theaters. The Princess Theater was made famous in the 1954 musical *A Star is Born* in which Judy Garland sang "Born in a Trunk." The song told about the birth of Garland's character at the Princess Theater in Pocatello.

The theaters and culture of Pocatello attracted a variety of fascinating individuals, including two presidents, Theodore Roosevelt in 1902 and William Howard Taft in 1908. Both men spoke on the grounds of Pocatello High School, which was constructed 1892. The high school had many important functions in the community. Used as the town's central meeting hall, Pocatello High School held concerts, town meetings and sporting events. It was the most majestic building in the region; it was a vital part of the up-and-coming city and is still an integral part of the city today.

As a Pocatello native, I have come to know and love the vibrant history of my beautiful city. I enjoy sharing the history and stories, which allow others to gain a new perspective on the past and perhaps peer through a window into our own future.

CHAPTER 1

THE GHOST OF POCATELLO HIGH SCHOOL

Pocatello High School loomed in front of Grant as his car turned the corner in the overcast morning light. Grant smiled as he came face to face with the prodigious school. It never failed to amaze him as he gazed at the beautiful architecture of the one-hundred-year-old school, and he marveled at how well it had withstood the test of time. The original school was built in 1892 and became the town square in the developing city of Pocatello. The community used the building for community plays, sports and Sunday picnics. The building was also an important gathering point for the region, even attracting two United States presidents to campaign at the school. In 1914, a fire in the boiler room caused a massive inferno, devastating the structure, burning it to the ground. It took three years to rebuild the school on the same spot as the original. Pocatello High School was reopened in 1917 and continues to stand as a centerpiece in Old Town Pocatello.

Grant was in a hurry because it was Thanksgiving morning. He had not finished his work from the night before due to a family event. His wife had gotten up with him to start preparing the delicious meal that would be waiting for him when he finished his work. It had been raining all night and Grant could still hear the rain falling outside. He walked the long halls of the massive high school, where he had been the janitor for over twenty years. It was quiet in the hallways, and Grant enjoyed the time to himself. Over the years, he had become accustomed to being alone in the century-old building. During his time at the school, Grant had heard of strange things happening when people were by themselves

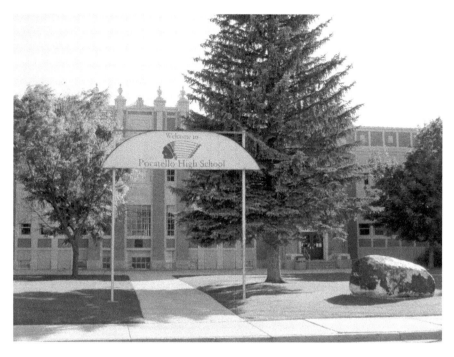

Historic Pocatello High School.

in the building. Many of the other janitors were apprehensive about being in the school alone.

Some of Grant's co-workers believed the school was haunted, but he did not believe in ghosts. One janitor told a story of being alone in a downstairs bathroom when all of the toilets began to flush at the same time. Another faculty member was called to the school when the elevator went crazy and began to go up and down all by itself. A repair man was called but never found the problem. Finally, there was the story of a young librarian who hanged herself on a chandelier. The urban legend said the librarian was in love but was left at the altar. She was so distraught that she committed suicide in the library. For over thirty years, people have seen the apparition of the lonely librarian standing in the library window.

Grant never let ghost stories bother him when he was at work. As he walked the hallways of the three-story building, he thought of all of the delicious food waiting for him at home. Turkey, pumpkin pie, cranberries, olives, salads, ham, mashed potatoes and gravy, followed by football after the evening feast. Oh, how Grant loved Thanksgiving. He rushed to empty

the garbage cans in the classrooms throughout the school. He knew he was close to being done and could return home to spend the rest of the holiday with his family.

Grant finished emptying the trash and took the bags out to the dumpster. He was disappointed to find the rain falling even harder than when he arrived. After finishing all the other responsibilities, Grant began his final task of the morning. He had purposefully left this job until last. Even though he had worked in Pocatello High School for more than two decades, he still felt anxious in the trophy room. The trophy room was the oldest part of the school. It was located in the middle of the building, just off the main hallway, across from the principal's office. Many called it the heart of Poky High because of its location and the feeling of stepping back in time. The awards of the past century filled the cases and acted as a reminder of the generations that had passed through the school. It was not the room itself that made Grant felt uneasy; it was the stairway located at the other side of the room. The stairway led down to an unused gymnasium, which had been a swimming pool many years before.

In the first part of the twentieth century, the pool had been used for swim meets until a tragedy occurred. It was believed that a student had drowned

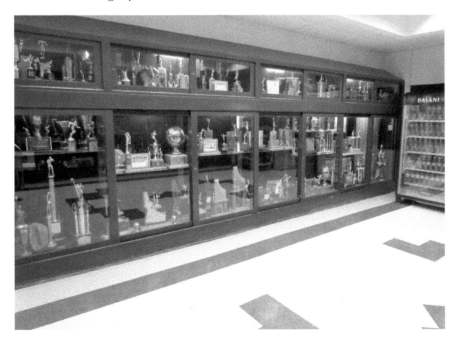

Trophy room, "the heart" of Pocatello High School.

in the pool, and the school had changed it into a gymnasium. Generations of Pocatello High students believed the gymnasium and trophy room were haunted by the spirit of the student who had died.

Grant began to mop the floor. He knew he was close to being able to return home to his family. He focused on the job, working quickly but with attention to detail. With each pass of the mop, the task came closer to the end. Soon he was at the back of the room, nearly done and nearly free. Grant dipped the mop one last time. As he pushed the mop across the floor, Grant began to sense he was not alone. He raised his head slowly and looked around the room. Everything was quiet, and then he saw him. A boy was standing in the doorway from the main hall. Grant was startled for a moment but then noticed the boy was dripping wet. He looked like any other boy, wearing jeans, sneakers and a red cotton jacket. The boy looked cold, scared and disoriented. Grant could feel the atmosphere change. The melancholy figure seemed to drain any light from the room. Grant was baffled as to why the boy was there or how he had gotten in the school.

"What are you doing here?" Grant asked.

The boy responded, "I came in out of the rain."

"Well, how did you get in? The doors are locked," Grant replied.

The boy flashed a shy, embarrassed glance and then looked away, hiding his face from Grant.

"No, I just came in out of the rain." The boy forced the sound from his lips as if it caused him great pain.

"Well, I'm sorry, son, but you can't be in here. I will walk you to the door," Grant said as he turned to put the mop back into the bucket.

Grant looked away from the boy for only a second, but when he turned to walk him out, the boy was gone. He was not startled because he thought the boy had quickly started down the hall heading for the door. As Grant entered the main hall, he suddenly realized no one was there. The hallway was too long for the boy to have made it to the door. Even if he had run, there were no doors he could have ducked into. Grant ran to the end of the hall where it was crossed by another hallway that spanned the width of the south end of the building. It was empty. The high school was large and had many entrances from the outside. The problem was the alarm system; it would have sounded if any of the entrances were disturbed. Grant had rearmed it when he came in. Still, he checked every door, but they were all locked and the alarm was set.

With each passing moment, the uneasy feeling in his stomach began to grow. Grant knew what he had seen but could not accept what it meant.

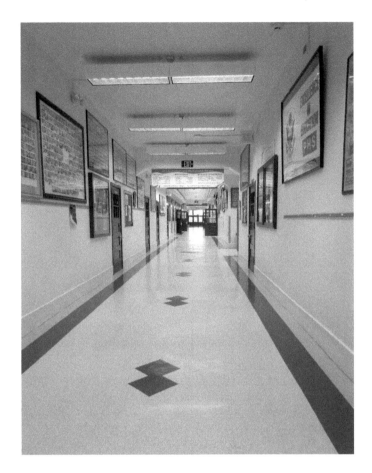

Main hallway in
Pocatello High
School.

He began to rationalize how the boy could have left the building without setting off the alarms. All of the doors in the school were locked except the bathrooms. Yes, the bathrooms did not have doors, and the boy could be hiding in a stall. Systematically, Grant searched the bathrooms, one by one. He checked them all, both male and female, until they all came up empty.

What had he seen? Who was the boy? Why had he seemed so sad? All of these questions raced through his head. Suddenly it was too much, and Grant ran to the exit. He ran through the doors as fast as he could and didn't even take the time to put away his mop. He jumped in his car and drove home in the pouring rain.

Grant returned to the school and continued working there for many years. He never saw the boy again but always remembered the melancholy figure he met in the trophy room at Pocatello High School.

CHAPTER 2

SHADOW MAN

Denver was one those people you couldn't believe. With his Marilyn Manson look and combat boots, no one took him seriously. He was the drummer of a garage band and went everywhere on a skateboard. John and Caleb always made fun of him when he passed them on the street. His family owned a store in the old part of Pocatello, so Denver passed John's house almost every day. The two boys would yell at Denver to stop and tell them about his latest experience. Denver always had some crazy story about people following him, getting into fights or being abducted by aliens. John and Caleb would laugh at the far-fetched accounts and send Denver on his way, taunting him as he left. Denver seemed completely oblivious that John and Caleb were making fun of him. He was always willing to stop and share his outlandish tales. This routine continued until the day Denver invited them to the store warehouse.

School would soon be starting again as summer gave way to fall. John was enjoying the afternoon shooting baskets with Caleb in front of his house. As the boys finished their game of HORSE, a lanky figure dressed in black rolled down the sidewalk on a skateboard. When the figure approached the house, John grabbed Caleb's arm to alert him to who was coming. Denver rolled up to the driveway as John and Caleb stepped out onto the sidewalk.

"Hey Denver, what have you been doing?" John asked in a sarcastic tone. "Any more aliens following you around, and are they going to beam you up to the mothership?" John and Caleb laughed as they looked at Denver mockingly.

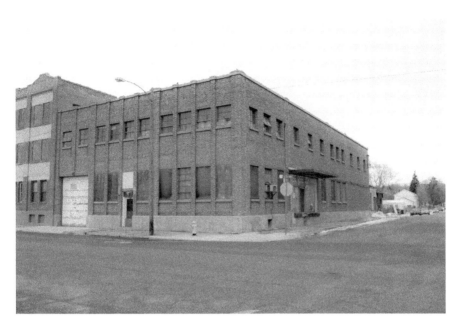

Historic warehouse on First Street.

"Oh, hey guys," Denver responded in his typical monotone voice. His long black hair covered his face as he stared at the ground. "I had something crazy happen to me last night."

"What, some guy jumped out of a dumpster and beat you up?" Caleb shouted, cutting off Denver midsentence.

"No, that's a good one, but it was something down at my family's warehouse," Denver continued his story with a new passion in his voice. "I couldn't sleep last night, so I went down to the warehouse at two in the morning. I like to practice on my drums at night when it is nice and quiet. When I got down there, I went into the room where my drums are, and I noticed my drumsticks were missing. I started looking for them all over the building, and I finally found them in the back in the freight elevator. I don't know how they got there, but I know I didn't put them there. Anyways, so I go back to my drums and start practicing. While I'm playing this song I wrote for my mom, I get this feeling I'm being watched. I get up and start walking around. It's about three in the morning now, when I see this guy standing in the back by the freight elevator, but he wasn't like a normal guy, he was just a shadow. I'm looking at him when he starts chasing me. I ran up to the second floor, and the whole time I'm looking back at this shadow man

chasing me. Finally, I make it to the front door, and I get out of there. I ran all the way home but not before I grabbed my board."

"That is incredible," John responded with a smirk on his face. "Man, you were lucky not to get caught by that shadow man. I hear shadow men are about the worst thing you can tangle with."

"Yah, I was lucky to get out of there alive," Denver said with some concern. "That shadow man doesn't want me playing my drums because of the noise. That is why he hid my drumsticks."

Caleb couldn't contain himself any more. "Denver, you are such a liar! Why do you always tell us these stupid stories? We know you made them up."

"No, it's the honest truth." Denver pleaded. "I can prove it to you guys. Meet me at the warehouse tonight at two, and I will show the shadow man to you."

John and Caleb looked at each other hesitantly. John spoke first, "I don't know if I can get out that late."

"Yah, two in the morning is pretty late to be out down by the railroad tracks." Caleb added.

"Come on guys, I go down to the warehouse at night all the time. It doesn't bother me even with the shadow man chasing me," said Denver, suddenly switching to the offensive. "I mean, you guys aren't scared, right?"

"No, we aren't scared," both John and Caleb responded together. "We'll be there at two, and we'll prove there is no shadow man."

"OK dudes, I'll meet you in front of the warehouse. Don't be late," Denver confirmed as he skated away.

Caleb spent the night at John's house. They slept outside in the backyard so they could leave without being noticed. The time arrived, and the two boys headed down to the old part of town. The warehouse was located on First Street, next to the railroad yards. The yellow light from the street lamps gave the road an eerie glow. The trains filled the air with the sound of diesel engines and the occasional boom as the train cars came together.

Denver could be seen standing in the doorway of the brick building as John and Caleb arrived. "Glad to see you made it. I was afraid you wouldn't come," Denver shouted.

"Of course we came; you don't think we would miss the chance to prove you wrong," Caleb answered.

The three boys walked slowly into the large brick building. The building had been erected in the early 1900s and had two main floors. The outside was made of tan brick with a long line of broken and boarded-up windows. Denver flipped the light switch as they entered the main room. The

fluorescent bulbs flickered as they came to life. Even with the lights on, the room only seemed to be half lit, leaving patches of darkness throughout the building. The interior of the first floor was filled from top to bottom with boxes of old merchandise. Pathways from room to room had been formed between the walls of freight. Denver led the way to the backroom. John and Caleb followed him, trying not to disturb the merchandise that seemed to be on the verge of collapsing in on them.

When the group arrived in the backroom, it became obvious the building had been a functioning processing plant in the past. Piles of abandoned equipment were heaped from floor to ceiling. The back of the building was dark even with the lights on, and it took a minute for John's eyes to adjust. On the back wall was the aging remnant of a loading dock with large doors that look like they had not been opened in years. To the left-hand side was an old-style freight elevator with a pull-down gate. Denver stepped into the elevator bay and turned to John and Caleb.

"Here we are," he said as he looked up the elevator shaft. "This is where the shadow man lives. I saw him come out of this shaft and look at me in the other room. I can't tell you too much about him except he moves fast and doesn't like my drumming."

Corridor back to the elevator shaft where the shadow man was seen.

"You come down here at night when you can't sleep?" Caleb spouted, "This building is creepy; no wonder you have been seeing things. This place will mess with your head if you let it."

"I didn't imagine anything," Denver responded. "The shadow man is real. Follow me."

Denver proceeded to walk back into the first room, followed by John and Caleb. On one side of the room was an open space between the walls of freight. In the void Denver had created an area where he could practice his drums. He sat down on a small stool and picked up his drumsticks. Denver shot a quick glance down the hall toward the elevator and shouted as if he was speaking to someone standing there.

"The shadow man hates it when I play this song. I wrote it for my mom. It's called 'The Woman that Bore Me.'" Denver began to bang away at his drums.

John could understand why the shadow man would be angry; the song was horrible, without any rhythm or time. The two boys listened to Denver wildly play his drums for what seemed to be an eternity. John and Caleb stood looking around the building for any sign of the shadow man. Finally, Denver finished playing and laid down his drumsticks. He stood up and looked down at the dark elevator.

"I guess the shadow man is asleep," Denver said shaking his head. "I don't think he wants to come out and play."

"Or maybe he doesn't exist," Caleb exclaimed. "I think we can get out of here now that we know the truth: there is no shadow man."

"I agree, let's go home," John added as he looked angrily at Denver. "We have wasted our night, and I'm tired. We have to get up in a few hours, and tomorrow is going to be a long day."

"Guys, I didn't make it up," Denver pleaded. "I really did see the shadow man. I guess he didn't want to come out tonight."

"Denver, you're a liar, and we should have never come down here with you," Caleb scolded as he turned and began to walk toward the door.

Suddenly, a large crash came from the back of the building. The three boys jumped and turned quickly to see what had happened. The air turned cold, and the sound of shuffling came from the dark corners of the room.

"What was that?" John shrieked. "Can you hear that noise? It sounds like something is moving."

"I can hear it," Denver answered. "I think we should go check it out."

"What! Are you crazy? I'm not going down there." Caleb's voice had gone three octaves higher.

As the boys talked, the noise grew louder. Suddenly, a black mass began to form in the darkness of the back wall. The three boys stood silent as they watched the black figure take shape. The noise of shuffling had been replaced by the eerie whisper of voices, too muffled to be understood. The dark figure's head, arms and legs could be clearly seen as the mass began to move slowly against the wall. With a jolt, the dark figure jumped forward out of the darkness and into the light. Only the outline of his body could be seen without a single recognizable feature.

"It's the shadow man, run!" Denver screamed as he turned to escape from the black figure. The three boys rushed out of the building at a full sprint. Denver slammed the door closed as he left the building and followed John and Caleb back to the house. When they arrived in John's backyard, the three boys collapsed to the ground, out of breath. They did not speak for a few moments as they regained their composure. Finally, Caleb broke the silence.

"I'm sorry we didn't believe you. I will never doubt you again." Caleb motioned to Denver with his hand.

"I told you the shadow man was real," Denver replied. "But I can understand how you guys didn't believe me. I know people think I'm weird."

"Don't worry about what people think," John answered. "From now on, you can hang with us."

"Thanks, that sounds great," Denver's voice beamed with joy. "We can go around and investigate some weird stuff that has been going on by the railroad yards. Have I told you about the little green alien and how he has been following me around?"

John and Caleb just stared at each other and laughed.

THE LIGHT

Willow loved her son Aaron. He was barely four years old and was a very smart child for his age. Willow loved him so much that she hated to be away from him for any amount of time. In order to keep him with her, Willow took a job in the old part of town where they allowed Aaron to come to work with her. Other employees also brought their small children to work, and the children played in a large open room during business hours. The employees set up a large television with movies and games to keep them entertained during the day while the adults worked. The job was perfect for Willow, or at least it was at the beginning.

Several months had passed since Willow started her new job. Everything was going well until one day in April. Willow had been busily working in her office when she stepped out to check on Aaron. As she came into the room, she became aware of the absence of any children. Perplexed as to where the children had gone, she began to call out Aaron's name.

"Aaron, sweetie, where are you?" Willow gently called.

Willow's pleas did not attract Aaron but did alert her co-worker Natalie, who came out of her cubicle to see what was wrong. Natalie had brought her daughter Heidi, a favorite playmate of Aaron's, to work. Both children were close in age and had similar personalities. Natalie and Willow had also become friends. Natalie had worked in the building for many years and brought her other children to work until they were old enough to attend school.

"Where did all of the children go?" Natalie asked as she and Willow glanced around the room.

"I'm not sure," Willow responded. "They were playing here just a few minutes ago. I am sure they are close by, but maybe we should look for them."

"I think they might have gone up to the second floor," Willow responded. "Those kids like to play up there with all of that stuff in storage."

The two women walked to the back of the building, where a steep flight of winding stairs separated the basement from the first and second floors. The building itself was constructed in the early 1900s and was a massive structure. The company the women worked for was a construction company, so the building was filled with equipment. The main floor was used for offices and small-item storage. The basement was a cold dungeon-looking room, packed with large equipment, signage and construction materials. The top floor was used as storage for the company, as well as employees' personal storage.

As Willow and Natalie arrived on the top floor, they could see two small figures huddled in a far corner. They casually walked toward them, and as they got closer, the sound of voices became very clear. The children were staring into the corner talking to each other very softly. Both women thought this was an odd game for the children to be playing.

"What are you guys doing?" Natalie asked.

Both children's heads snapped up as if they had been unaware of their mothers' arrival. They had a peculiar look on their faces as if they were doing something secretive and had inadvertently been discovered.

Aaron was the first to speak. "Mom, we were just having fun. We have been playing a game with our new friend, but he can't come up here."

"What do you mean a new friend?" Willow questioned.

The two children looked at each other with hesitation. "Well, we have been playing with a boy who lives down in the play room." Heidi responded, "He can't come up here, but his mommy lives here so we came to talk to her. We are telling her that our friend is OK."

"That is a strange game to be playing," Willow said, as her eyes moved back and forth from the children to Natalie. "Who is this boy you are playing with?"

Without hesitation, Aaron blurted out, "His name is Lock, and he died."

Willow was so surprised by the response that she had to pause and make sense of what she had just heard from her son. Willow continued her questions. "Died? What do you mean died? Is that part of the game?"

"No, he died, and his mom died, too," Heidi said happily. "But they can't be together because of the grumpy old man in the basement."

Main floor of the warehouse where the little boy has been seen.

Second floor where children communicated with the mother of the little boy.

By this time, Natalie had heard enough and interrupted, "So you kids are playing that game again. Willow, I'm sorry I didn't tell you about this earlier. Since I started working here, some of the kids have played a game about the grumpy old man in the basement. The game goes like this: there is a boy who lives on the main floor whose mother lives on the second floor and a grumpy old man who lives in the basement. The grumpy old man guards the stairs so the mother and son can't be together. The children take messages back and forth so the mother and son can communicate. My older kids use to play it when I brought them here. I'll admit it sounds a little creepy, but it's harmless."

"No, Mom, he is real, just like you and me," Aaron's voice was serious and direct, even for a child. "His mom is real, too. Her name is Ruth, and she wants to make you believe in her. She is standing over there," Aaron raised his hand and pointed to a dark corner on the other side of the room. Willow shuddered as she turned to look for Lock's mother, but there was no one there.

"Wow, I think it is time for you kids to come back downstairs," Willow said as she turned back to the children. Natalie stood motionless, bewildered at the strange statements. With a slight hesitation, the two women quickly picked up their children and went back down to the main floor.

The days that followed were uneventful, but Willow was bothered with by the events on the second floor. The idea of Aaron talking with a dead person bothered her and made her question what was right. Natalie did not seem to mind the strange game. Her children had been coming to the building for years, and they seemed fine. Willow finally came to the conclusion that the game was nothing more than an imaginative entertainment passed down from the older children. Aaron and Heidi continued to play with Lock, and in the game, the children spoke with him often. After two weeks, Willow paid little attention to the children's game—until she had to spend some time in the basement.

Spring was always the busiest time for the construction company. A new bid had just come through, and Willow had to go down to the basement to get some of the signage needed for the job. She asked Natalie if she would come down and help her since it required some heavy lifting. It was late morning when the two women went down the wooden staircase. Willow always felt a little claustrophobic in the basement since it was so full of equipment. The aisles were narrow and snaked around the jam-packed room.

The women quickly began to pull out the required signs since neither of them liked the uneasy feeling that saturated the dark basement. As

27

they set the last sign to the side of the pile, both women suddenly felt the temperature around them plummet. They looked at each other with questioning eyes, as a misty vapor became visible. The women could see their breath coming from their mouths with each exhale. The atmosphere changed as an overwhelming sense of anger and fear fell upon the room. Willow realized with panicked apprehension that the grumpy old man was in the area with them. Natalie stood close to Willow as both panned the obscure light, searching for the cause of the malevolent presence. Willow barely caught sight of a ten-foot-long metal bar that hurled itself at the feet of the two women. The bar landed with a deafening crash, as the two women made a mad dash for the stairs.

Out of breath, Willow and Natalie reached the playroom on the main floor. Aaron and Heidi stared, confused as to what was wrong with their mothers. Natalie quickly walked to the children and knelt next to them.

"What can you tell me about the grumpy old man in the basement?"

"He is a mean man and does not like people to touch his things," Heidi related.

"Things? What things doesn't he like people to touch?" Natalie asked with urgency.

"The things in the basement. He thinks everything belongs to him. Just like he thinks Lock and his mother belong to him," Heidi responded shyly.

Willow picked up Aaron and looked him in the eye. "Lock and his mother are real. I'm sorry I didn't believe you."

Natalie's face changed to an expression of sadness and concern as she spoke. "How horrible it must be for them being so close but unable to be with each other. We have got to try to help them. Has Lock ever tried to reach his mother?"

"Yes, but the only way is through the stairway, and the grumpy old man scares Lock," Aaron said timidly.

"It sounds like they are trapped," Willow added. "I do not know what we can do for them."

"Maybe we can help them pass over," Natalie said as she gestured to Heidi. "We can use the kids to communicate with them. I will do some research, then we can try to help them after work."

Willow looked nervous and unsure, but she nodded yes to the plan. The week ended, and a new one began. Natalie read as much material on the subject as she could. It was decided that the following Friday would be the day they would attempt to help the spirits pass to the other side. As the day approached, both Willow and Natalie grew more nervous.

It was 7:30 on Friday night when the building was finally clear of all other employees. Only the two children and two women remained in the building. They began to prepare for the task that lay ahead of them. Natalie explained to Willow the information she had gathered during the week.

"The first thing we should do is try to make contact with the spirit. Then once we are in communication, we should tell them to go into the light. The light will take them to the other side. Other than that, we will just have to wing it."

"OK, Aaron and Heidi, are you guys ready?" Willow asked the two smiling children.

"Yes, Mom, I'm ready," Aaron responded.

"Is Lock here? And if he is, can you talk to him?" Natalie inquired.

"Lock is here. He is sitting right next to me," Heidi said excitedly.

"OK, honey, this is really important," Natalie looked Heidi directly in the eyes. "Tell Lock he needs to look for a light, and when he finds it, he should try to go into it."

Heidi began to repeat what her mother had told her. As she spoke, the look on Aaron's face began to look more serious. When Heidi was finished speaking, the children paused for a while as if they were listening intently. Aaron finally broke the silence.

"Lock said there used to be a light but that it went out. Lock's mother told him not to go into the light. She was scared to go into it because of what she did. Then the grumpy old man came to take them away but Lock's mother told him to hide. It got dark, and his mother got lost. Lock is hiding from the grumpy old man."

"What did his mother do?" Willow asked with anticipation.

"She was a bad mother," Heidi said solemnly. "There was an accident, and that is why she screams at the top of the stairs. The only place for them to go is to the basement with the grumpy old man."

The children stopped speaking as their eyes moved toward an office door. A look of worry came across their faces.

"Mom, Lock just ran away," Aaron spoke fearfully. "The grumpy old man is coming. He said we need to hide."

Willow and Natalie grabbed their children and left the building quickly. They both continued to work for the construction company for many years, but neither mother ever brought her child to work with them again.

CHAPTER 4

FRAZIER HALL

Lisa was a student at Idaho State University working on her BA in sociology. It was the beginning of the fall semester, and Lisa hoped to be able to graduate in the spring. As she looked at her transcript, she realized there was a problem. One of the electives required for her to graduate had not been fulfilled. Lisa looked for a class that would satisfy the requirement and came across Introduction to Theater Arts 101. The class fit her schedule perfectly because it was being offered at seven in the evening at Frazier Hall, which was close to the Sociology Department. Lisa signed up for the class and began preparations for the upcoming semester.

The first day of classes arrived, and Lisa walked to the northwest corner of campus where the building was located. Frazier Hall was built in the 1920s and served as the theatrical stage for the university. The beautiful building had three floors and a basement. The exterior was pure white plaster with large windows across the front. The main theater was located just inside the entrance and seated nearly eight hundred spectators between the base floor and balcony. Lisa walked into the theater and took a seat in the middle row. Several other students sat sporadically around the theater and waited for the professor to arrive. Finally, Professor Bloomquist arrived on stage and began the class.

"I would like to welcome you all here today," Professor Bloomquist dictated in a dramatic voice accompanied by a wave of his hand. "In this class, we will explore the history of theater. We will begin with the Greeks and end with contemporary works being produced today on Broadway. We

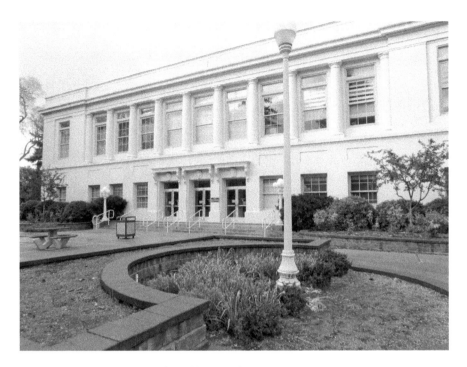

Historic Frazier Hall on Idaho State University's campus.

will spend extra time on the complete works of Shakespeare and especially *Macbeth*, which is being performed by the Idaho State Drama Club later in the semester. You will be required to attend the play and write an original essay on the deeper significance of what the play means. Now, if there are any questions, you may ask them now."

A male student in the back of the auditorium raised his hand and asked an unusual question. "Isn't the play Macbeth all about the paranormal things like witches and ghosts?"

"Ah, yes. It was considered to be a supernatural thriller in its day." Professor Bloomquist's voice exhibited a sudden peak of interest. "In fact, the paranormal has been a major theme throughout the history of theater. One of you may use this topic as the theme for your final paper. Spirits and ghosts have always been an important part of the theatrical community. I don't think I have ever been to a theater where there weren't stories of hauntings and strange occurrences. Actors have always been a superstitious bunch, historically."

"So, is this theater haunted?" a brown-haired girl sitting toward the front probed.

Professor Bloomquist chuckled and responded, "I cannot say if this theater is haunted or not but there have been several stories of ghosts told over the years. Some of the drama students swear there is a spirit who haunts the dressing rooms below the stage. I believe they call him Alex, but I think he is more of an ongoing joke than a real ghost."

A girl sitting on the right side of Lisa continued the questioning by asking, "Have you ever seen a ghost?"

Professor Bloomquist smiled and raised his hand to his mouth. He gently rubbed his fingers over his goatee as he paused to think about how to respond to the question. Then, as he gazed up to the empty balcony, he responded honestly. "I cannot say that I have seen a ghost, but I have experienced some strange things in my life. I believe there are things we do not understand or that cannot be explained. Part of this class explores what we call the human condition. Death is part of life, and how we deal with our own mortality is an important part of how we understand ourselves."

The class continued as the discussion turned to the day's lecture. Lisa enjoyed the earlier debate on the paranormal. It made her excited to write her final paper. Since she was a sociology major, Lisa planned on using some of her research to write a paper on the theater and how it illustrated the human condition.

Weeks passed, and the autumn chill of October covered the university campus. The play *Macbeth* was scheduled to be performed at the end of the month. Lisa had made plans to see the play with some friends, thinking it was a great way to fulfill her class requirement and have a little fun. The week before the play, Lisa attended her regular class at Frazier Hall. During the lecture, Professor Bloomquist discussed Shakespeare and the significance of different characters within his plays.

"Since we are coming up on Halloween, we should discuss the use of spirits or ghosts in the works of Shakespeare," Professor Bloomquist said, as he walked out from behind the curtain and across the stage. "*Hamlet, Julius Caesar* and *Macbeth* are just a few of the plays that have ghostly encounters in them. One main point we can take from this reoccurring theme is how prevalent the belief in ghosts was during the time of Shakespeare. Do you think things have changed in modern thinking, or have they remained the same? By a show of hands, how many of you believe in ghosts?"

Lisa didn't know how to respond to the question. She looked around the auditorium to see if others would raise their hands. A few hands shot up immediately while others slowly rose as they overcame their embarrassment. After a moment, the room seemed to be split, with about half of the

students affirming they did believe in ghosts. Lisa felt uncomfortable with the question. She had always been a very logical person, and questions about the supernatural took her out of her comfort zone.

"Wonderful. As you can see, we are not so different from the people who lived during the time of Shakespeare," Professor Bloomquist continued on with the lecture with his usual inquisitive tone. "I would dare say there are many more of you who believe in some form of life after death. There are very few people who believe that when we die it is the end, like a light going out. Most people believe we continue in one form or another. We see many references to this belief in our modern culture, from vampires to angels. The theme of life after death is very profound and touches the very core of what drives us as human beings. We are no different today than from the people in the time of Shakespeare, maybe just a little more educated and diverse."

After class, Lisa found herself pondering the questions that had been asked during the lecture. Lisa was deep in thought when she arrived at her car and realized she did not have her purse. It was now 8:30 at night, the sun had set and it was getting progressively darker. Quickly, Lisa began to hurry across the shadowy campus in order to get back inside Frazier Hall before it was locked for the night. The wind blew the leaves across the quad as she rushed past the different buildings on campus. It took her a few minutes to traverse the grounds, but when she arrived at Frazier Hall, she was relieved to find the door was still open.

The building seemed completely empty, without a single student left inside. Lisa walked swiftly through the lobby toward the entrance of the theater. The auditorium was dimly lit and completely silent. Hurriedly Lisa marched to the front middle row where she had been sitting. With a sigh of relief, she saw her purse sitting on the floor just under the chair in which she had been sitting. As she reached down to pick it up, a feeling that she was being watched came over her. Rapidly, she looked up and saw a man looking at her from the balcony. He looked like any other middle-aged man with a balding head and clean-shaven face. He had on a gray windbreaker, as if he were some kind of event staff for the theater. Lisa was startled for a moment but regained her composure, thinking he was just someone working in the building.

"Hello, I'm sorry. I had to come back to get my purse." Lisa yelled to the man on the balcony. "Are you trying to lock the building up?"

The man's countenance suddenly changed as if he was hiding and was unexpectedly discovered. With a single motion, he turned and began to run

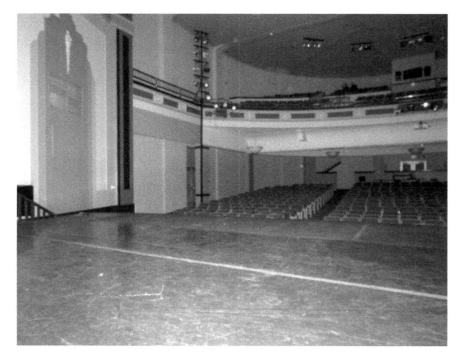

Main auditorium in Frazier Hall.

to the door on the right-hand side of the balcony. The sound of his keys jingling on his belt could be heard echoing throughout the auditorium. Lisa watched him run in disbelief, not understanding what she had done to make him panic. As he reached the door, the man suddenly vanished, and the entire auditorium was silent again.

Lisa was dumbfounded. She spoke out loud, asking herself where the man had gone. "Did I just see someone disappear? Did he just vanish into the door? Is someone playing a trick on me?" Lisa paused as she waited for a response, but there was only deafening silence.

Lisa felt very uncomfortable. She quickly walked out of the theater but could not stop herself from scanning the area as she left. As she hurried back to her car, Lisa rationalized what she had seen. Maybe he had been embarrassed that she had discovered him staring at her and ran out of fear, but why did she not see or hear him go through the door? Did she really see him disappear, or had her imagination gotten the best of her because of Halloween and the talk of the paranormal in class? By the time Lisa reached her car, she was completely confused.

The next day, Lisa decided to visit Professor Bloomquist and ask him about her experience the night before. Professor Bloomquist had his office on the third floor of Frazier Hall. Lisa felt anxious walking back into the building. The professor was sitting at his desk with the door open when she arrived.

"Hello, Lisa, how are you?" Professor Bloomquist asked as he raised his head from the pile of papers on his desk.

"Professor, I hope I am not disturbing you," Lisa's voice sounded apologetic and nervous. "I need to ask you a question about something that happened to me last night."

"Of course, please come in and take a seat." Professor Bloomquist stood and moved a chair closer to the desk for Lisa to sit in. "Now, what happened? You seem concerned."

"Professor, we have been talking a lot about ghosts in class, and I think I saw one last night," Lisa stated as Professor Bloomquist listened intently. "I left my purse in the theater after class, and when I came back to get it, I felt like I was being watched. I looked up on the balcony, and I saw a man standing there. He looked like a normal middle-aged man and was wearing a gray windbreaker like some of the event staff wears. I called out to him, but I guess he got scared because he began to run toward the door. I could hear his keys jiggling as he ran, but when he got close to the door, he vanished. It sounds crazy, but I know he didn't go through the door because when he disappeared there was no sound of the door opening and closing."

Professor Bloomquist listened to Lisa's story and paused for a moment before responding. "So, you say you saw this man in the balcony and that he was wearing a gray windbreaker. You also believe this man disappeared because you did not hear the door open or close, but you heard his keys jiggling when he was running. Is this a good summary of what you experienced?"

"I guess so," Lisa replied sheepishly.

"Lisa, let me begin by saying I believe you," Professor Bloomquist reassured Lisa. "There are so many things we do not understand in this life, and this may be one of them. I have to believe that throughout history, people have talked about these types of experiences because they are more common than anyone could ever imagine. I need to ask you a favor. Can you come to my office next Monday around three in the afternoon?"

Lisa agreed to the meeting and left to attend one of her other classes. The next few days left Lisa with a feeling of anticipation. She was curious to find out why Professor Bloomquist had asked her to return and meet with him. The weekend passed, and Lisa returned to his office

at the agreed time. She was surprised to see an elderly lady sitting with Professor Bloomquist in his office.

"Lisa, welcome, and I would like to introduce you to Ester Getty." The women shook hands and sat down as Professor Bloomquist continued. "Ester is from Austria and came here many years ago after World War II. I have been friends with her for a long time, and she has a story to tell you."

Ester's eyes focused on Lisa, and with a heavy accent, she began her narrative. "The man you saw in the theater was named Fritz, and he was my husband. He died ten years ago of a heart attack. Fritz loved the theater more than anything in this world and volunteered in Frazier Hall as an usher. When he passed on, his spirit came back to Frazier Hall so that he could be close to his passion. You are not the only person who has seen him. I have seen him also, and he let me know he is happy."

Ester then placed a picture of a man on the desk. His bald head and clean-shaven face was instantly familiar to Lisa. It was the same man she had seen in the theater. Lisa was shocked at the revelation.

"I do not know what to say," Lisa muttered. "This is incredible. Fritz is the same man I saw in the theater."

"I know, dear," Ester explained. "Remember, you scared Fritz more than he scared you. He is not used to being seen. Normally, he can come and go without anyone noticing. You must be very special to have been able to see him."

"Do you really think so?" Lisa asked with a sense of intrigue.

Professor Bloomquist answered, "Of course—why else would you have taken my class?"

The three laughed and spent the rest of the afternoon talking about Ester, Fritz and the couple's amazing journey through life. Over time, Ester and Lisa became good friends. They loved to attend the theater together and always made sure to invite Fritz.

CHAPTER 5

LA PALOMA

Mary delighted in knowing she owned one of the best Mexican restaurants in town. It was located on Main Street in the historic Old Town section of Pocatello. Her own building was surrounded on all sides by the beautiful aging edifices, remnants of the city's colorful past. Old Town had a charm all of its own, reminding her and her patrons of a time now gone. Mary purchased the building in the 1970s while it was being operated as a pizzeria. At the time of purchase, Mary discovered that her little restaurant had housed many different businesses over the years. She was shocked to learn that a tire company, a burger hut and a hardware store were only a few of the business that had once occupied the building. The structure was old and had been built at the turn of the century. The biggest surprise came when she heard rumors that the building was initially established as a burlesque, where men came to watch scantily clad women dancing on stage.

The little Mexican restaurant was very popular and always had a crowd of people who loved the food and the quaint atmosphere. Mary loved to share her Hispanic heritage and was proud to present her culture through her food. She ran the restaurant with her husband, Frank. They believed in a family-run business and were happy to employ several of their children and a few close family friends. In the morning, Mary and Frank would arrive before the rest of their family to begin food preparations for the lunch crowd. When customers arrived, they entered through a glass door leading directly into the restaurant from Main Street. The door opened into one of the restaurant's two dining rooms. The front dining room had

a large picture window, so it was very bright with the sunlight naturally illuminating the space. The kitchen took up the middle of the structure with a narrow, dimly lit corridor for the customers to walk through leading to the second dining room. The back dining room was very different from the front. There were no windows allowing sunlight to break up the room's dimness, and the atmosphere was dark and heavy. The back door was solid wood and had a small vestibule with an outside door leading to a small parking lot. Even when the back door was propped open, very little light came into the room. In the mornings, the back door was left unlocked so the different food deliveries could be made without hassle. There was a loud bell on the door so when the deliverymen came in, Frank or Mary could attend to them quickly.

The morning began like so many before it. Mary and Frank arrived at the restaurant and began to prepare the meat and beans to get ready for the lunch crowd. The morning had not been busy, with only a few deliveries of bread and milk. It was 10:30 a.m. when Frank sat down for a short break. Mary walked to the back of the kitchen to check on the food. To her surprise, someone was sitting at a table in the second dining room. As Mary stared

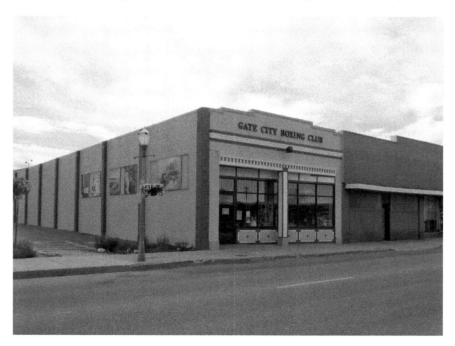

Former La Paloma building in 2013, now the Pocatello boxing club.

into the dimly lit room, she could tell the person was very unusual. The figure appeared to be a woman clad in a long red dress with a large-brimmed hat that covered her face. Mary's first thought was that maybe the woman had come from church or a funeral. Mary felt very uneasy about the lady all dressed in red because the restaurant didn't open for another hour and they had not heard the bell ring when she had come in the back door. Mary ran to the front, where Frank was sitting at a table reading the newspaper.

Mary and Frank both spoke with a Spanish accent. When they were alone, they spoke Spanish, but when they were at the restaurant, they always spoke English.

"Frank, Frank. There's some lady sitting at a table in the back and she's all dressed up, like she just came from church or something."

"OK, well, go tell her we don't open for another hour," Frank responded without looking up from his paper.

"Oh, you go tell her. I'm not going back there. I got a weird feeling," Mary answered back anxiously. "Why don't you go take her some chips and salsa? Tell her I can make her a taco or something quick."

"OK, I'm going," Frank responded with an exasperated sigh. He laid his *Idaho State Journal* on the table and grabbed the items he needed. He walked through the kitchen and entered the back dining room. As soon as he entered the room, he understood why Mary had been so bothered. The lady in red was sitting at the table with her head tilted so that the lowered brim of her hat concealed her face. Her dress was very elegant and appeared to be made of silk. Decorative lace covered the entire dress from top to bottom and even extended to her hat. As Frank approached her, he felt a sadness about her, as if she had just lost someone very important to her.

"Hello, my name is Frank," he said in his best English. "You know, we don't open for another hour, but that's OK. My wife, Mary, said she could make some tacos if you would like?" Frank began to set the table. He set the chips and salsa next to the lady and handed her the menu.

"Thank you. I'm sorry. I don't want to be a bother," the lady in red spoke softly. "Tacos would be fine. I just want to sit here for a while and rest."

"OK. Do you want me to bring you something to drink?" Frank responded.

"Water would be fine," the lady in red answered.

Frank returned to the kitchen. Mary had begun to make the tacos. She prepared the plate with beans and rice. Mary glanced out of the kitchen at the lady in red as she sat quietly without a movement. Even from the kitchen, Mary could feel the atmosphere become heavy and gloomy. Mary placed the tacos on the plate and handed it to Frank. He took the plate out to the table

and set it down in front of the lady. She hardly moved, as if she didn't notice Frank was there. He was about to ask the lady if there was anything else she needed, but before the words could come out, his attention was drawn to the far corner of the room. Suddenly, there was a hiss and a small shadow darted out from under a table. Frank was taken aback as he saw a black cat dash across the room.

Frank rushed into the kitchen. He asked himself how a cat got in as he hurried to the front of the restaurant. He had only opened the door twice for two delivery men that morning. By this time, he had caught Mary's attention.

"Frank, what happened?" Mary questioned. "Why are you running?"

Frank arrived at the front of the building and reached around a corner to grab a large broom.

"There is a big black cat back there. Come help me catch it," Frank roared.

Mary and Frank rushed to the back, but as they went through the swinging doors, the lady in red was gone. The only thing that remained was an untouched plate of rice, beans and tacos. The two immediately began to look under the tables for the black cat, but it was also nowhere to be found. They looked at each other with wide eyes, wondering where the lady in red and the cat had gone. Frank rushed to the door and opened it with a loud ring from the bell. He stood looking from the open entrance at the empty parking lot, puzzled.

"Where did they go?" Frank asked, vexed. "We were only gone for a few seconds. There is no way that lady walked out of here without us seeing her. Why did we not hear the bell?"

Mary had joined Frank in the entrance. Her eyes scanned the area, trying to find a hidden figure to no avail. She looked at Frank and said stridently, "I told you there was something weird about that lady. Who comes in here dressed like that? Oh, no. I'm going back inside and getting ready to open."

A few days later, an old friend came in for a bite to eat. Charlie was eighty-two years old, with a quick wit and always a story to tell. He had lived in Pocatello all of his life and had retired from the railroad after forty years of service. Charlie loved to tell Mary stories as she prepared the food for her customers. As they talked, Mary told Charlie about the mysterious lady in red.

"Oh, Charlie, I got to tell you about this strange lady that came in here the other day. She came in, and we never hear the bell at the door. Then I made her a taco but then this big black cat comes in the restaurant. Frank and I grabbed a broom to chase it out, but when we get to the back room, they are both gone. Poof, like they just disappear."

Charlie's eyes flashed as a funny grin came across his face. "A lady and a cat, you say, and the lady was dressed all in red, wasn't she?"

"Oh, yes, Charlie! How did you know?" Mary exclaimed.

"Well, I've been meaning to tell you that story," Charlie continued with his usual charm. "The lady and the cat you saw are ghosts. I know because I've seen them before. In fact, a lot of people have seen them. No one knows who they are, but I believe she was a burlesque girl who worked in this building. She always seems so sad, like she's waiting for someone who never comes, and the cat always comes to take her back to wherever she came from."

Mary's face showed her total astonishment at the story. "Charlie, are you saying my restaurant has ghosts?"

"Yes, I guess they came with the building. You did read that in the fine print?" Charlie joked. "Don't worry, they're harmless. They are a lot like me: old and pop in from time to time."

Mary laughed, "Si, but what upset me the most was that she didn't eat my tacos!"

THE HAUNTED DEMOLITION DERBY CAR

As the cars lined up around the arena, Gene could feel the transformation beginning. Gene was a quiet, unassuming man until he got behind the wheel of his demolition derby car, and then he became the most feared man in the West. He had won many championships on the derby circuit. He was known for his outrageous driving style and no-fear approach to smashing his car into others. He loved to hit anything that got in his way. With his savage method of driving, it was no surprise that Gene needed several new cars in a single season. For this event, Gene was trying out a new car he had just finished building. The car was a great find. The body was in perfect condition, and the engine did not need much work. This was not usually the case, since Gene salvaged his derby cars from the local junkyard.

The green flag waved, and the destruction began. Gene was a monster, taking out several competitors with hard-hitting blows. He drove with the pedal to the floor, smashing and swerving across the dirt arena. There were only three cars left about fifteen minutes into the contest, when suddenly, Gene's car stopped. He turned the key to restart the motor, but the engine was dead. Gene sat in his car, dejected as he watched the other two cars finish the contest. As he waited for the tow truck to come and pick him up, Gene turned the key one last time. To his surprise, the car started right up as if nothing was wrong.

When Gene got back to his shop, he began to take the car apart to find what had caused the motor to shut off. He replaced several parts in the engine, believing they may have been the problem. The following week, he

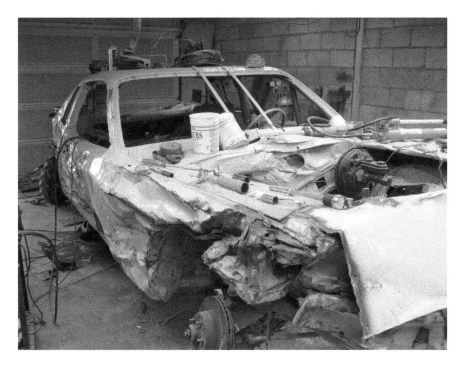

The haunted demolition derby car.

took the car to another demolition derby out of town. The car worked great. Gene was overjoyed as he smashed the other cars in the arena into oblivion, until once again suddenly, the engine stopped running about fifteen minutes into the event. Gene was furious and could not believe it was happening all over again. He had no choice but to once again sit idly by and watch until the derby was over. As the derby ended, Gene, on a whim, turned the key, and the car started without a problem.

The same thing happened every time Gene took the car to an event. He should have won many of the derbies he entered, but as each contest approached the end, the car would stop and would not restart until the derby was over. Gene disassembled and reassembled the engine several times, swapping out parts until only a fraction of the motor was original. Gene asked his bother Kevin to help him find what was wrong with the car. The decision was made to start over and put in a completely new motor. Gene and Kevin placed the new engine on the side of the car in the shop. They planned to meet the next evening to begin work on the car.

The next day, Gene and Kevin met at the shop as planned, but when they opened the door, they knew something was wrong. The new engine had been destroyed. The piston rods were pulled out of the engine block; it looked like it had exploded internally. Oil covered the floor, and little pieces of metal could be seen scattered on the ground. The brothers had no explanation for what had happened. The door had been padlocked, and there were no signs of a break-in. They began to clean up the mess and figure out what to do next.

As the brothers worked, a strange feeling came over them. Kevin noticed that a hazy mist seemed to come from one of the walls in the shop. Both brothers stopped as they watched the mist become larger and thicker. As the cloud grew, it began to swirl around the car, moving in and out of the windowless cabin. Gene grabbed a camera he kept in the shop to document the repair work done on the derby cars. He began to take pictures of the weaving mist. After a few moments, the vapor began to dissipate and enter into the trunk of the car. Gene had welded the trunk shut, so there was no way to open it and see what was going on

The damaged engine block from the demolition derby car.

inside. As quickly as it had begun, the phantom mist ended, seeming to evaporate into the trunk. The brothers were left speechless, wondering what they had just witnessed. After talking about it, they decided to pack up the equipment and leave.

Kevin had been so affected by the swirling mist that he refused to go near the shop anymore. He told Gene he was on his own and would come back when he got a new car. Gene returned to the shop, where he was left alone to fix the car as best as he could. The destroyed engine was no good to him now, so he decided to take it to Dave, his friend at the junkyard. Dave's junkyard was where he had originally purchased the car. When Gene arrived, he began to ask Dave about the origins of the mysterious car.

"Dave, I've got this engine for you. I know it's in bad shape, but I'm sure you can find a use for it. By the way, I need to ask you about that car I bought from you a few months back."

"Oh, you mean the Chrysler," Dave said pensively. "What do you want to know?"

"Well, for starters, where did it come from, and was there anything strange about it?" Gene probed.

"I'm not sure where it came from, but the truck that brought it had Wyoming plates on it," Dave said as he struggled to remember. "It did seem strange to me that someone would come all the way here to Pocatello just to dump a car. The last time I checked, there were plenty of junkyards in Wyoming. It was odd that the owner paid in cash and made it very clear he wanted the car destroyed. You don't see many cars in that good of condition come through a junkyard, so that's why I called you."

"Do you know the name of the man who brought it to you?" Gene inquired.

"No, it was a cash deal, but I did get a title from him," Dave said as he headed toward his office. "Let me go see if I can find it." He disappeared into the tiny house he used for the junkyard headquarters. A few moments later, Dave returned with a paper in hand. "Here it is, and just like I thought, he is out of Casper, Wyoming."

Gene took the document and thanked Dave for his help. The name on the title was Bill Knopp. When Gene got home, he checked the internet for a Bill Knopp in Casper, Wyoming. There was a listing for him with an address and phone number. Later that evening, Gene called the number.

The phone rang, and a man's voice said, "Hello?"

"Hello, my name is Gene, and I am trying to reach Mr. Bill Knopp."

"This is Bill Knopp. What can I do for you?"

"Well sir, this may sound strange, but I'm calling about a car you left at a junkyard in Pocatello, Idaho."

The phone was silent for a moment, and then Bill, who was obviously upset, roared, "That car was supposed to be destroyed. I paid cash to crush that thing until there was nothing left. Where is it now?"

"I have it, sir, and I understand you may be upset, but I really wanted to find out the history of this car," Gene pleaded. "There have been some very weird things happening, and I need to find out why."

"I won't tell you about the car, but what I will tell you is that it is cursed. That car has seen its share of evil. My suggestion is take it to the junkyard and destroy it as soon as you can. That car is still mine, and if it is not destroyed within a week, I will get my lawyer involved," Bill said and slammed the phone down, ending the call.

Gene was perplexed by the conversation, and the words Bill had said worried him. After thinking about how the car could not finish a derby, the experience he had with the mist and the strange the conversation with Bill, Gene believed there was something wrong with the car. The following day, Gene drove the car over to the junkyard and had it crushed.

Gene was not happy about having the car crushed but figured it was less of a hassle than dealing with the original owner. Dave had just received another car that would be perfect for the demolition derby. He showed the car to Gene and sold it to him on the spot. The only problem was that it was missing the bumper. Secretly, Dave removed the bumper from the original car before it was crushed. He threw the bumper in the backseat of the new car as Gene was signing the paperwork.

CHAPTER 7
BANNOCK COUNTY COURTHOUSE

The Honorable Judge Joe Miller had just been appointed to the Bannock County District Court. The courthouse, a large building that took up an entire city block, was located at the intersection of two prominent streets in the center of town. Judge Miller's office was on the top floor, next to his courtroom. The building had very tight security and cameras in every corner. Hector was the head of security and was about to complete twenty years on the job. Judge Miller's impression of Hector was that he was a serious man with little to say. Hector always had a nose for trouble and always expected the unexpected. The two men had spoken but never for more than a minute or two and never on a personal level, until late one night.

Judge Miller was in his office late on a Friday in order to finish some work. It had been a long evening; the clock on the wall read 10:00 p.m., and the judge still had not finished. Deciding to come in over the weekend to finish his work, he grabbed his coat and headed out of his office into the hall. As he marched down the hall, he saw Hector walking toward him.

"Working late, Judge Miller?" Hector greeted him in his stern monotone voice. "It must be important; you wouldn't find anyone else here at this time of night."

"Oh, just some odds and ends I've been trying to put to rest," Judge Miller replied. "You make it sound as if my colleagues are afraid to put in a little overtime."

"No, they all work overtime, but you were correct when you said afraid," Hector spoke as he stared with his cold, dark eyes.

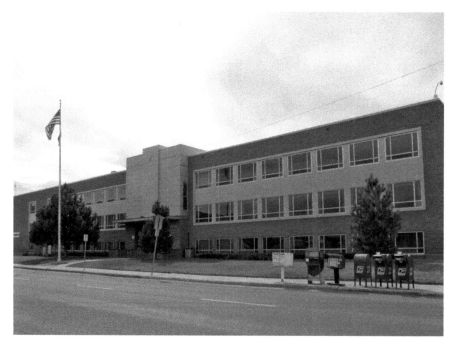

Bannock County Court House on Center Street in Pocatello.

"Afraid? What do you mean?" The judge responded with a puzzled look on his face. "Are you afraid of something bad happening to me in the parking lot?"

Hector chuckled and shook his head. "No, I do my job better than that, Your Honor." Then he raised his head and looked the judge directly in the eyes. "Hasn't anyone told you? Strange things happen here at night, things that can't be explained."

"You mean like…like…ghosts?" the judge stuttered.

"Yah, crazy stuff like that," Hector responded with a strange grin on his face.

Judge Miller paused, bewildered by Hector's candor. "Well, you have been here for, what, twenty years? Do you believe this place is haunted?"

Hector paused for a moment as he gathered his thoughts. "Well, I have seen some strange stuff. Last Christmas Eve, I stopped by to pick up some wrapping paper I had inadvertently left in my office. It was 11:30 at night, and as I walked up the stairs I could hear what sounded like a party going on in the courtroom. I heard music, laughing and voices as if a large group of

people were in there. I knew no one was supposed to be in here, so I rushed in to see who it was. I opened the door ready to confront the individuals, but no one was there and all the noise was gone."

"Wow, that's a wild story, but do you believe it really was ghosts? I mean, maybe a radio was left on," the judge responded, making it apparent he did not believe anything he was hearing.

"I looked for the source of the noise when I came into the room. I also thought it must have been a radio or some other electrical device left on. I could not find anything to explain the sound, but that is not the only strange occurrence I have witnessed. There have also been things on the cameras," Hector continued with the same unapologetic attitude. "One morning I came in to find a large information board ripped off the wall. The security cameras in that hallway take a picture every three seconds. When I reviewed the footage, the security board is on the wall in the first picture, and in the next, it was twenty feet down the hall, lying on the floor. It was three o'clock in the morning, and no one had been in the building for hours. I have no logical explanation for why that board would be on the floor and down the hallway in a three-second period. "

"That's incredible! I would love to see that footage," the judge replied incredulously.

"Well, that's not all," Hector continued. "There have been lots of experiences here in the offices. Just last summer, several of the clerks went to lunch together but could not get back into their office because their desks had been pushed up against the door. There was only one door to enter and exit the room. When the room was finally reopened, there was no one on the inside. Then on election night, one volunteer came running out of the vault screaming that a man had walked out of the wall toward him. The volunteer was so upset that he left and never came back. Finally, there was the night I was walking by one of the doors with a punch-code security pad. As I walked past, I heard a sound that made me stop and look at the door. I watched it open by itself with my own eyes. I can honestly tell you it was not caused by anything natural like the wind. Those doors can't open without the code, and it set off all the security alarms."

By this time, Judge Miller didn't know what to say. All he could muster was a simple, "Wow."

As Judge Miller drove home, he was puzzled that a man like Hector would tell such wild stories. What bothered him the most was he almost believed him. Hector had spoken with such unflinching conviction that he couldn't deny his self-assurance.

The weeks passed, and summer gave way to autumn. As the days grew shorter and the nights grew darker, the judge continued to work late nights. Many times he was the only person in the three-story courthouse. Sometimes he would think about the stories Hector told him, but he never saw or heard anything out of the ordinary himself. As time went on, he consigned the stories of paranormal events to the realm of overactive imaginations and scaredy cats.

Another busy week came to an end, and the judge was once again working late. His eyes grew tired as midnight approached. The judge grabbed his coat to leave when he heard a noise in the hall. Walking out of his office, he could see the silhouette of a person standing at the end of the hall. As his eyes adjusted to the low light, he became aware that there was a woman standing in the shadows. The judge was surprised to see her at such a late hour because the cleaning crew was normally gone by this time. He called out to her to see who she was.

"Hello! Excuse me, who are you?"

The figure stood motionless and silent.

"Are you with the cleaning crew?" the judge shouted as he walked toward the woman.

Instead of responding, the woman simply stood quietly as the judge continued toward her. The closer he got, the more nervous he became. He began to see her long blonde hair covering her shoulders but could not see her face. The judge began to be very annoyed at the woman's silence.

"Hey, who are you? Why are you in here?" the judge called out to the woman. "You shouldn't be in here. I will need to walk you out."

Suddenly, the figure moved, turning her face away from the judge as she began to run down the hallway. He instinctively began to chase her. The long hallway made a ninety-degree turn where it became a short corridor atop a flight of stairs leading to an outside exit. He was gaining ground on the figure and reached out to grab her as he watched her turn the corner. He wanted to catch her before she got to the stairs and escaped through an exit. As he turned the corner, he expected to see her just in front of him, but to his surprise, he found himself alone. The judge ran to the stairs, but they were empty.

"Where did she go? I should have seen her on the stairs," the judge muttered to himself. "At least I should have heard her opening the door, and the alarms are set, so why didn't they go off?"

Quickly, the judge walked to the exit and pushed the door open without putting in his pass code. Immediately, the alarm sounded until

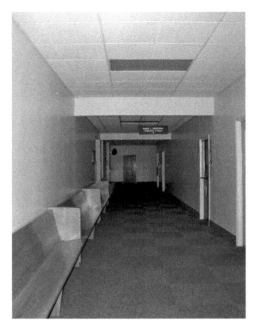

Third-floor hall where a woman was seen.

the judge silenced it from the control pad. Not wanting to investigate more, he walked into the parking lot and drove away in his car.

The following Monday, the judge requested that Hector review the security tapes. He told Hector about the woman and how she had eluded capture. Several hours later, Hector walked into the judge's office with a peculiar look on his face.

"Did you look at the security tapes like I asked?" The judge prodded tensely.

Hector sat in a chair and folded his arms. Raising his head to look out the window, Hector responded, "Yes, I did, Your Honor."

"Well, where did she go? How did she get away?" The judge asked confoundedly.

Hector puckered his mouth and looked at the floor. He took a deep breath and exhaled through his nose. The he raised his chin and, in the same monotone voice, replied, "I watched the tapes, sir, but all I saw was you running down an empty hallway."

The judge sank into his chair. His eyes glazed over as his mind vanished into his own thoughts. He began to wonder if what he had seen was real.

Hector motioned to the judge to get his attention. "Don't worry, sir. It's like I said—strange things happen here. Over time you'll get used to it, just like me, and I won't mention this to anyone. It's our little secret."

"Thank you, Hector," the judge said as he stared at the wall. "I'm sure over time we will have many unusual experiences to talk about."

Hector chuckled and then answered, "Of that, I have no doubt."

CHAPTER 8

WAITING FOR SARA

J ack Silver was a talented local artist. His specialty was painting scenes from the Old West. He loved painting cowboys riding across a sagebrush-filled desert, driving cows to their final destination. He had gained some notoriety and traveled all over the United States promoting his work. He made his home in Pocatello but also kept residences in Nevada and Arizona. Every winter, he and his wife, Karen, traveled to Arizona to escape the harsh Idaho winter. During their winter hiatus, the couple met many interesting people as they traveled to different art shows in the area. They enjoyed meeting new people and had made several lifelong friends.

It was late February when Jack and Karen went to Yuma, Arizona, for an art show. It was like many other shows they attended. They set up their displays and began to talk to the people as they stopped by to look at the paintings. Later in the morning, a tall, lean figure stopped by their booth. His name was Leo Thomas; he was a tall Native American and a member of the Navajo Tribe. Leo was a fan of Jack's work and was excited to finally meet the artist. The two men made an instant connection. They spent most of the day talking about the Wild West and cowboys riding across the Arizona desert. As evening approached, Leo began to talk more about his home on the Navajo reservation. He owned many acres of land where he raised horses. Each member of his family had his or her own horse that they had raised from a foal. As Leo spoke, his voice grew solemn when he told the story of Sara, his oldest daughter.

"Sara was my daughter, and she was so full of life. I remember when we gave Sara her colt. It was her birthday, and my mare had given birth to a beautiful filly. We did not know that when we gave her the filly she would spend day and night with her. She named the horse Saguaro after the white desert flower that grows around our ranch. She loved that horse, and it was faithful to her always. When she would leave, Saguaro would wait by the gate until she returned. That horse never let another soul ride her, and only Sara could take her into its stall at night. They were quite the pair," Leo paused as he cleared his throat. Jack was still as he listened to the story intently.

"Sara was twenty-one when she decided to go out into the world. She was eighteen when she joined the army. We begged her not to go, but she had a desire to see other places and serve her country. She was trained as a nurse in the army, and they sent her to war. Every day that horse stood by the gate waiting for Sara to come home. Sara was sent as a nurse on the front lines. Her letters described how she had been thrown into a difficult part of the war. She had been there for almost a year when she was sent to a very hostile area. No one knows exactly what happened, but Sara was reported missing in action. Time went on, and we waited, but there was no word of what had happened to her. The war ended, and we lost hope that she would ever come home. Years have passed, but Saguaro still waits every day for Sara to come home. That old horse still hasn't lost hope."

Jack's eyes glistened as he listened to Leo. He was truly touched by the cowboy's story of loss. The two men spent the rest of the day swapping stories and talking about times gone by. After the show, Jack and Leo agreed to stay in touch.

Jack and Karen returned to Idaho for the summer. As the weeks passed, Jack was haunted by the story of Sara and Saguaro. In his mind, he began to envision the lonely horse waiting for its master to return home. Jack began to paint what he saw in his mind's eye. He painted the red desert with the high bluffs in the background. He painted the lonely horse, ever vigilant, waiting by the corral fence. As the painting took shape, Jack saw the vision more clearly with each stroke of the brush. Months passed, and the cool air of fall came to Idaho. Soon it would be time for Jack and Karen to return to Arizona.

October came, and it was time to go back to Arizona. Jack had finished the painting. There was something very special about this piece. As Jack looked at it, there was a sense of déjà vu even though he had never been there previously. Before Jack and Karen left Idaho, Jack contacted Leo to tell him he was returning to their winter home. Jack and Karen were invited to

Local artist Golden Millward and his painting.

visit Leo on his ranch. Jack decided to give the painting to Leo as a gift to let him know how deeply his story had touched him.

As Thanksgiving grew near, Jack and Karen drove north from Holbrook to arrive at Leo's ranch. Jack had a funny feeling as he watched the red landscape become more and more familiar. As they pulled into the ranch, Jack immediately noticed the large bluffs in the distance. A sense of astonishment came over him as he walked to the house; he instantly recognized the landscape from his painting.

Leo greeted the couple and invited them into his home. Leo introduced them to his wife, Marcia, and his two daughters, Eleanor and Ruth. They spent the afternoon getting acquainted, laughing and telling old stories. After a while, Jack spoke up and began to tell the story of his painting.

"Leo, I was so touched by the story of your daughter Sara and her horse. All winter I couldn't get it out of my head. In fact, I thought about it so much I made a painting for you." Jack pulled the painting from a large canvas bag he had brought into the house with him. Everyone focused on the painting intently as he displayed it for the family.

Photo of painting *Waiting for Lori*.

"Oh, that is amazing," Marcia exclaimed, "and you captured the landscape so well! You even painted our red bluffs."

"Well, you see that is the strange part," Jack muttered as he looked to the ground. "This painting just came to me. It's hard to explain, but parts just seemed to paint themselves. I have never been to this part of Arizona before, but as I stepped out of the car today, I felt like I had been here many times before."

"This is definitely a work of inspiration," Leo whispered. "You caught the true spirit of the relationship between Sara and Saguaro."

"And you even painted an Indian girl!" Ruth cried as she pointed to the painting.

"What?" Jack asked as his head turned to the woman. "I didn't paint any people."

"It's not a full person," Ruth explained. "It's a silhouette." Ruth then proceeded to draw the outline of a native girl on one of the red bluffs in the background. The outline could be clearly seen in what was meant to be a large shadow on the side of the cliff face. The outline of the body descended

until it reached the back of the horse waiting at the gate. Then on the side of the horse, the shadow continued forming the outline of a leg, as if the figure was mounted on the horse's back.

Jack was amazed as he scrutinized the outline of the Indian girl. "I don't know where she came from. I didn't mean to paint her there."

Leo, now standing next to Jack, put his arm around Jack's shoulders and whispered, "For the longest time, I thought Sara was lost to us, but now I know she has come home." The rest of the morning was filled with tears, smiles and laughter as the gathering talked about the ghost of the Indian girl in the painting.

As the afternoon moved on and the sun shone over the red bluffs, Jack and Leo walked out together to the corral. Saguaro met the two at the gate and stared at them with his old sinning eyes. Leo patted Saguaro on the nose and then rubbed his neck gently. Jack was still taken aback at how closely the horse and the bluffs resembled his painting. Leo's eyes panned the red bluffs as if he were expecting to see Sara standing off in the distance.

"It is hard to remember that this life is just a part of something bigger than us all. I know my daughter is here in the wind, the earth and now her spirit has become part of this place," Leo paused as he continued to rub the horse's head. "I guess we can only hope to have family and friends as loyal as old Saguaro."

Saguaro suddenly pulled his head away from Leo and trotted away toward the red bluffs as if he was being guided there by some unseen rider.

Jack and Karen left later that evening and returned to their home. A year passed before they saw Leo again at an art show in Littlefield. Following their normal pattern, Jack and Leo spent the afternoon catching up and telling stories. During their conversation, Leo informed Jack that Saguaro had finally died of old age and had been found in between the red bluffs. Leo explained that after Jack's visit, Saguaro never again waited by the gate in the corral and spent most of his time in the hills. Leo believed that Sara and Saguaro were now together riding the red hills as they had done when they were young.

CHAPTER 9
CAVE IN THE DESERT

Jerry Stone was a professor at Idaho State University. He taught reptilian biology and was an expert on the Western Diamondback Rattlesnake. He loved his job at the university and enjoyed teaching his students. Jerry also had a fifteen-year-old daughter named Deborah, whom he affectionately called Deb for short. Their favorite pastime was to drive out onto the desert, just west of town, and hunt for snakes. The desert was a high plains desert full of sage brush and basalt rock formations. There were several lava tube caves that plunged deep into the earth; one of the deepest was the Crystal Ice Cave. The Crystal Ice Cave was originally used for centuries by the Native American tribes in the area for shelter and food storage. As settlers began to homestead in the area, they learned of the cave and began using it for their needs. The cave was so deep that ice formed year-round, hence the name. Unfortunately, the cave had to be closed in recent years due to vandalism and the dangers the cave posed to the people who ventured inside.

It was the end of May, and the school semester had just ended. Jerry looked forward to the long summer days spent with Deb exploring the desert. Mark Gage, a friend of Jerry's at the university, also enjoyed going to the desert but for a much different reason. Mark loved to go spelunking. It was a thrill for him to find large holes in the ground and rappel down into them. Mark had invited Jerry and Deb to come with him and his son Bill to do some spelunking during the summer. Jerry thought it sounded fun and agreed to the invitation.

It was a warm, sunny morning when Jerry, Deb, Mark and Bill set out for the desert to enjoy a day of spelunking. They all crowded into Mark's old pickup and headed down Interstate 86.

"So, where are we going?" asked Jerry.

"Well, this is a secret spot," Mark explained. "Have you heard of the Crystal Ice Cave? It is a lava tube 160 feet below the surface at its deepest point, and it goes on for over a mile. There are parts so big you could drive a diesel truck through it, even though the main entrance is small. The ice cave entrance is closed, but there are other entrances all over the desert. This entrance we are going to is near a rock formation under the sage brush. It is hard to find, and only a few people know where it is."

"Wow, that sounds great," Deb interjected. "I can't wait to get there."

"Oh yeah, well, Dad didn't tell you the part about the ghost," Bill roared out with a smirk on his face.

"What?" Deb responded. "What do you mean a ghost?"

"Bill is just trying to scare you," Mark replied with a joking tone. "Many years ago, there was a tragedy out on the desert. A teenage boy was lost while on a camping trip. People from all over formed search parties and looked for him for more than a week, but they couldn't find him."

High plains desert outside of Pocatello.

"So they never found him?" Jerry inquired, his interest sparked.

"Well, that is where the story gets weird." The good-humored tone had left Mark's voice and was replaced with a somber pause as he gripped the steering wheel. He had a vacant stare as his eyes scanned the highway. "You see, they looked for him for weeks. People from all over Southeast Idaho helped in the search by donating food, water and horses. Many volunteers came out to the desert and looked for him on foot. There was no trace of the boy." Mark scratched his head nervously as he continued. "There was a man who had come out to the desert to help in the search. He was camping out there, and he had a dream one night. He said the boy came to him in his dream and showed him where he was. The next morning, the man got up and went to a crevice near the Crystal Ice Cave. The fissure led into the cave, and he followed it down. When he reached the bottom, the first thing he saw was a leg sticking out from under a large crack in the cave wall. The man knew it was the boy because he had been wearing rolled-up blue jeans, white socks and Nike running shoes when he went missing. Unfortunately, the boy had died of exposure. Since then, people say the spirit of the boy haunts the cave. People claim they hear his voice, and others even claim to have seen him."

"Yeah, and Dad's friends saw him, and now they won't go back in the cave anymore," Bill exclaimed in his animated voice.

"Now Bill, that's enough," Mark scolded. "My friend Sanju is an avid spelunker. Last fall, he was going down into the cave when he claims to have seen something. I don't know what he saw, but he goes to other locations now to have his fun. I think it best we get off this subject before we get too caught up in superstitions."

The rest of the drive was filled with fun and laughter. Everyone in the truck soon forgot about the strange story of the lost boy in the desert. The group exited the interstate at American Falls and headed toward Aberdeen. Halfway to Aberdeen, they turned onto a sportsman access, which quickly changed from a paved to a dirt road. The desert soon appeared out from the miles of potato fields. In the distance, a large lava rock hill could be seen getting closer. As the pickup pulled up to the desolate hill, Deb felt a shiver go down her spine. It surprised her because it was a beautiful day and everything seemed fine.

The group got out and unpacked their gear. Mark led them to the far side of the hill and pushed the sagebrush out of the way. There on the hillside was a large metal dome. Mark and Bill pulled it off to one side, exposing a large vertical hole. The hole was small on the top but quickly

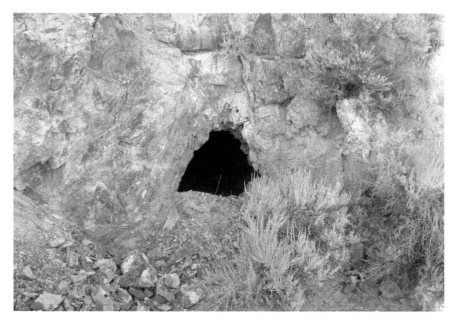

Cave opening in the desert outside of Pocatello.

opened into a large shaft plunging forty feet straight down. Each member was strapped into a harness and given a helmet. Since Jerry and Deb were inexperienced, Bill went down first while Mark helped on the top. Each person took their turn lowering themselves into the cave. Mark had brought a wench, which was very useful in helping Deb and Jerry get to the bottom without too much trouble.

The cave was massive, cold and dark. The temperature even during the summer was below freezing. The giant columns of ice went from the ceiling to the floor. Each member of the group had a headlamp and a flashlight, but the darkness still seemed to surround them on all sides. The tiny group began to explore the cave as they tiptoed across the icy floor.

"This cave is amazing!" Deb exclaimed. "It's like being on a movie set or something."

"It's a good thing it stays so cold down here, or we may have run into wolves or coyotes," Jerry's voice echoed down the chamber.

"OK, let's head down to the main chamber," Mark said as he pointed into the dark chasm.

The group entered a large chamber with sloping sides. Deb immediately noticed that the room was lighter. As her eyes adjusted, she noticed that

there seemed to be a small opening to the surface on one of the sloping sides. Jerry and Mark began to walk to the far end of the chamber, while Deb and Bill stayed near the entrance.

"This place is really cool," Deb whispered. "I wish I could stay down here all day."

"It would be OK as long as you had your gear and warm clothes," Bill explicated, "but can you imagine being down here alone with no food or warm clothing? Even during the summer, the nights can get chilly out here."

Suddenly, Deb felt the temperature drop, as if a cold breeze had come into the room. An uneasy feeling came over her as she turned to look to see if Bill was feeling the same. He had a strange confused look, as if he was focusing on something he could not comprehend. As the two stood in silence, a small whisper echoed off the wall. It was so soft it could barely be understood.

"I'm over here."

Deb watched as Bill's face went from confusion to terror. The next thing she knew, Bill was gone. Frenzied for a moment, Deb began to look around with her flashlight. Suddenly, a painful groan emanating from the ground caught Deb's attention. She quickly turned her light on Bill lying on the ground.

"Oh, my leg!" Bill moaned in pain.

By that time Mark and Jerry had come back from the other side of the cave. They immediately attended to Bill.

"Are you OK?" Mark asked. "Is anything broken? How did this happen?"

"No, I just twisted my ankle," Bill responded sheepishly. "I just want to get out of here. I don't know what happened. I was standing there, and I must have slipped but...I don't know...it was like my legs flew out from under me."

Mark and Jerry helped Bill hobble back to the harnesses. Since Bill was hurt, Mark went up first to help at the top. Being an experienced spelunker, he quickly pulled himself out of the cave without the assistance from the wench. Bill was hooked up to the wench and was lifted out of the cave. As Deb waited with her father, she didn't know how to tell him what was on her mind. She finally decided just to say it.

"Dad, you know how we were talking about how that boy died in this cave? Well, I don't know what exactly happened to Bill, but right before he fell, some really strange things were happening. It got cold, and it felt like someone was watching us. Then I swear I thought I heard someone say, 'I'm here.'"

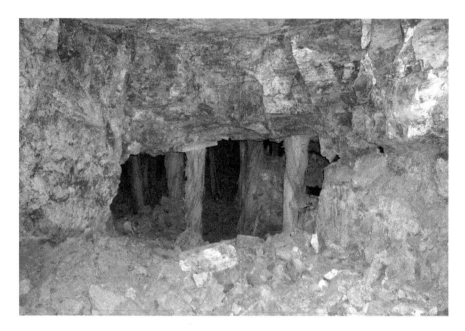

Inside of the cave where the ghost boy has been seen.

"Deb, I'm sure there wasn't anything abnormal going on. It's dark, and your imagination can play tricks on you," Jerry explained with his fatherly voice. "The voice you heard was probably Mark and I talking."

Finally, the harness was lowered, and Deb strapped herself in. She ascended into the hole at the top of the cavern. As Jerry waited for his turn, he felt unusually nervous. He sensed a chill come over his spine, and his hair began to stand on end. As he looked around the cave, he noticed a slight glow from another chamber. The glow began to grow in intensity and take form. Jerry was astonished by what was happening in front of his eyes. The glow was coming from a gap where the floor and wall met. The harness had come back down. Jerry hastily put it on and gave the signal to lift him up. As he was being raised, he looked back at the gap where the glow was emanating. The glow was now a recognizable shape. As Jerry exited the cave, he could clearly see a short, skinny leg sticking out of the gap. It was clothed in blue jeans with the tops rolled up to expose the white sock, and the swoosh logo on the shoe was unmistakable.

CHAPTER 10

THE HAUNTED LOCKER

It was the weekend before Halloween, and Lisa had tickets to the Haunted History Tour in Old Town Pocatello. The tour was an annual event exploring the reportedly haunted buildings in the historic section of Pocatello. The tour was very popular, and if you did not get your ticket early, chances were you would not get one. The tour would sell only a limited number of tickets, and it sold out every year. Lisa was going with two of her friends, Ellie and Megan. They were all very excited and had planned a fun night listening to ghost stories. Lisa's mom was also coming because she was driving and would be chaperoning the group.

The tour began at 6:00 p.m., when the sun was just beginning to set. There were five locations on the tour. They were lucky to have Allison as the tour guide because she was so good at telling the stories. Allison had so much information about the area and eagerly answered any questions the group asked. The girls loved listening to the history of the old buildings, and the stories of paranormal activity were exhilarating. The tour allowed the guests to enter many old structures in the historic section of town. They were able to see hidden areas within the buildings normally off limits to the public. Allison told the group that during all of the tours in years past, there had been people who experienced or saw paranormal events. The thought of experiencing something extraordinary gave Lisa a strange sensation of terror and excitement all mixed into one.

It was dark as Allison led the tour group to its last stop. It had been a perfect night with a full moon illuminating the way. As the group approached

its final destination, Lisa realized they were headed for a familiar place: her high school. Pocatello High School was an enormous stone structure built in 1917. The original building was built in 1882 but had burned to the ground in 1914. For more than a century, students had passed through the school, and their pictures lined the walls of the extensive halls. Allison led the group though the doors of the massive building and walked them to the top floor into the library. All three girls giggled with anticipation to hear haunted stories about their school.

Allison began the tour telling the stories of ghostly figures seen walking the floors of the school. The girls listened intently, imagining what it must have been like to experience something so unusual. The tour led the visitors through the corridors on all three floors. Allison took them to the basement for the final stop. The group gathered around a set of old lockers and a small janitor's closet across from the girl's bathroom.

"To end the tour tonight, I would like to tell a sad story." Allison paced around the group making eye contact with each guest as she spoke. "Sometime in the past, there was a girl who attended this school. People say her name was Violet, and she always wore violet perfume. For whatever reason, Violet and a friend decided to make a suicide pact in which they agreed to hang themselves in their lockers. The girls' lockers were on different floors, so they split up to carry out their pact. At the last second, Violet's friend chickened out and did not hang herself. Unfortunately, Violet did not chicken out and took her own life. After this horrible event, the school began to have problems with the locker. Classes began to be interrupted because of loud noises coming from it. Students said the door would open and close by itself. It has been said books would suddenly come flying out and hit the wall. The locker was such a problem that the school decided to remove the locker and put in this small janitor's closet," Allison voice rang out as she pointed to the closet.

Lisa could feel the hair on her neck stand up with elation. The crowd gasped as they looked at the spot where this tragedy had occurred. Lisa looked over at her mother to see the reaction on her face because she was scared of her own shadow and refused to watch any scary movies. Lisa's mother shuddered with fright and was visibly ready for the tour to be over. Ellie and Megan both had smiles on their faces even though they were huddled together in fear.

"Now there is one last part to this story," Allison continued as she regained the crowd's attention. "Since the locker was removed, there have been no reports of any paranormal activity—except one thing. There have been

Location of the original haunted locker and present-day janitor's closet.

Basement hallway where the haunted locker is located.

reports that when people are in this area, suddenly an overwhelming smell of violet perfume will come out of nowhere, and that is how you know she is here. Thank you. This is the end of the tour, and we will meet in front of the building."

Allison led the group straight up the stairs and out the front door. As Lisa turned to follow, Megan grabbed her arm.

"Hey, will you come to the bathroom with Ellie and me?" Megan asked.

"Ok, but let me tell my mom." Lisa turned and yelled up the stairs to her mother, "Mom, wait for us outside, we are going to the bathroom." Her mother turned and gave a quick acknowledgment as she walked out the door.

The three girls entered the bathroom. The lights were dim, and the fluorescent bulbs flickered and hummed. The girls stood in a row looking into the mirror. They talked teasingly about the tour and how each one of them had been scared. Suddenly, a loud thud came from the hallway. The girls fell silent as they looked at each other in alarm.

"Did you hear that?" Ellie exclaimed.

"Maybe someone is outside?" Megan replied.

The girls slowly walked out into the hall. They looked up and down the empty corridor, hoping to see what had caused the noise. The girls jumped as another loud thud came from the janitor's closet. Lisa could see her friends were frightened as they shook in fear.

"Let's get out of here," Lisa frantically whispered.

"Yes, let's go. I don't like this place," Megan whimpered.

As the girls turned to go, they stopped in their tracks. The intense smell of violet perfume surrounded them. Each one stood for just a moment to make sure what they were experiencing was genuine. As the reality hit them, without a word, the three girls ran up the stairs and out of the building.

THE FACE OF THE DEVIL

Big Joe worked at a warehouse on First Street in Pocatello. They called him Big Joe because he was six foot three inches and 245 pounds of pure muscle. Joe was good at lifting the heavy boxes of merchandise and putting them on the trucks. He liked his job because everyone respected him for his strength and the amount of work he could get done in a day. All the ladies in the shipping office called Joe to do the jobs that were too big or difficult for them to do by themselves. Joe was the go-to guy if you needed to get something done. The only thing he didn't like about his job was working in the basement.

The basement at the warehouse was made up of several different rooms and a large freezer. The building was originally a dairy processing plant in the 1900s. The freezer was no longer functioning but was too big to be removed. A few years after the dairy had gone out of business, the freezer had been used as the morgue for the city of Pocatello while a new hospital was being built. Joe didn't like the idea of working where they kept dead people and even more so because of the things people said had happened in the basement.

There were stories of a doctor who worked in the morgue and did horrible things at night. The urban legend said he would use tunnels under the building to secretly bring his victims into the building unseen where he would perform experiments on them.

Whether the doctor existed was a matter of speculation, but there were signs of something evil in the basement. On the walls of the freezer were

Warehouse that contains what appears to be the face of the Devil.

patches of brown stains that formed the outline of bloody handprints. The rumors alleged they came from the victims of the doctor. The owners of the building had tried everything to get the stains to go away, even using acid to burn them off the wall, but eventually they always came back.

Besides the bloody handprints, there was another ominous indication that something malicious inhabited the area. The employees of the company called it the face of the devil. In the far corner of the basement was a small dark room that had a heavy feeling of despair. The room was featureless with gray concrete walls and a single light bulb dangling from the ceiling. In the top center of the outside wall was a black mark, which could be seen as one walked into the room. At first, one might mistake it as a simple black patch on the wall, but with further investigation, the features become very apparent. The black mark clearly formed a dark face with hollow eyes and a gaping mouth. The foreboding expression filled the room with dread and seemed to absorb the light like a black hole. The owners of the building attempted to eradicate the black mark by covering it with gray paint. The paint worked for a few weeks, but as the days passed, the face returned until it was as solid as it had been before.

Bloody handprints on the freezer wall.

Big Joe would only go into the basement if it he had to. Joe's boss, Terry, always made fun of him, saying, "How can a big guy like you be afraid of the dark?" Joe would respond, "It's not the dark I'm afraid of—it's that doctor who killed them people down there. I ain't never going to let him get me." Terry would just laugh and continue working. Terry had worked in the building for many years and never believed any of the stories he had heard about the doctor.

Mid-October was a busy time of the year for Big Joe. He spent much of his time filling the building with equipment that needed to be stored for the winter. By the end of October, snow could begin to fall, so long hours were spent bringing in the different pieces of equipment and getting them ready for winter storage. The top half of the building was always the first to be filled, but as the month moved on, it was clear that some items would have to be taken to the basement.

One beautiful fall morning, Joe arrived at work. He knew it was going to be a busy day. A full trailer was coming in, and he would be lucky to be done before dark. The first half of the day was normal, but as evening approached, the main floor became full and the rest of the equipment would

The "Face of the Devil" in the basement of the warehouse.

have to be taken to the basement. Terry had stayed until 5:00 pm but had to leave because it was his son's birthday. Big Joe was left to finish alone.

When Terry left for home, there was only about two hours of light left before the sun set. Joe worked quickly, wrapping each piece of equipment in plastic and then walking it down the steep stairs and placing it in the back corner. Joe did not waste any time in the basement and made sure he left as fast as he could. By the time Joe wrapped the last item in plastic, the sun had set, leaving the sky with a red autumn glow. The basement was dark even with the lights on. Joe quickly walked down the stairs, anxious to finish the job. He placed the item at the back of the room and headed for the stairs.

As Joe raced for the stairs, he could see the doors were all closed on three small rooms at the front of the basement. This gave him a brief jolt of pleasure because he would not have to take time to close them. He had nearly reached the stairs when he saw a figure in the corner of his eye. With a rush of terror, he turned and faced the open door of the freezer. Standing in front of him was a pale, blonde-haired girl. The white cotton dress highlighted her shining blue eyes as she stared at him with a blank expression. Joe's dark

skin had momentarily turned white, but he quickly regained both his color and composure. Joe bent over as he struggled to regain his breath and, after a moment of panting, began to speak.

Joe stood up and faced the strange little girl. "You almost gave me a heart attack. What you doing down here?" Joe questioned.

The little girl did not respond; she simply stood motionless with the same blank expression on her face.

Joe paused for her response, but when she remained silent, he angrily snapped, "Did you hear me? How long have you been down here?"

The girl's countenance changed as she became visibly agitated. Her shining blue eyes turned gray as they focused on Big Joe's face. The girl began to move her mouth as a small cold whisper escaped her lips. Her voice was soft, but Joe understood all five words: "I have always been here."

Suddenly, the doors on the three small rooms began to open and close wildly. The loud slams startled Joe as he whipped his head around toward the sound. He looked at the animated doors for only a moment and then returned his gaze to the empty freezer. The little girl had vanished.

Hallway in the basement where the doctor has been seen.

The doors abruptly stopped slamming shut, and for a brief moment everything was still. Big Joe stood paralyzed with fear. The freezer was about fifty feet long and had a large door at both ends. Joe watched with horror as the door at the opposite end of the freezer opened slowly. As the door swung open, a frightening apparition passed through the entrance. A hooded figure, dressed in a white uniform stained with red splotches of blood, walked into the room. His head was covered with a hood, which had a long protruding beak and two inlaid goggles. He wore bloodstained gloves, which held a knife in one hand and an old-style syringe in the other. Joe realized this was the doctor.

Dazed, Joe struggled to comprehend what he was seeing. When the bloody figure began to move toward him, Joe was thrust back into his terrifying reality. Overcoming his fear, Joe turned with a single motion and raced up the stairs. Terrified, Joe ran from the building, not even taking the time to close the door. He jumped in his truck and sped away, leaving the frightening apparition behind.

The next morning, Terry was upset to find the building open with the lights left on. He tried to call Big Joe but couldn't get him to answer the phone. Terry called for several days until he decided to go to Joe's house. When Terry arrived at the house, Joe refused to go back to work and told Terry he would never go into the building again. Not wanting to lose a good worker, Terry offered Joe a position on the road crew. Big Joe accepted on two conditions: first that Terry would never make fun of him again, and second, that all of the doors in the basement would be removed. To this day, Big Joe can be seen working on road projects around town and not a single door is left in the basement of the warehouse.

THE GHOST OF THE PIG FARMER

Karri was an ordinary girl living an ordinary life during the 1970s. Karri's family had moved from Arizona to Idaho the year before. Her family consisted of her parents and one brother and sister. They had moved into a house next to the Portnuef River on the outskirts of Pocatello, Idaho. Pocatello was named after a Shoshoni chief who led the tribe when settlers and the railroad came to the area. The railroad had come through in the 1860s, and Pocatello started as a rail stop for the steam-powered trains to refill with water. The town grew, and a century later, Pocatello had become one of Idaho's largest and most important cities. Karri loved her new home and planned never to leave.

As time went on, Karri made friends with her neighbors, especially Rocky, the old man who lived just down the road. Rocky was always telling her stories of when he was a boy. He had lived in the same house all of his life and knew just about everything about the area. Karri was fascinated when she learned that her house was built on a traditional campground for the Shoshoni tribe and Chief Pocatello himself had used the area for a semi-permanent encampment. Rocky also told her that when the railroad came to Pocatello, the lands given to the Shoshoni were taken away. The reservation was cut in half, and the tribe was forced to the north onto what was left of the original land allocation.

Pocatello grew quickly, and a very diverse group of people came to the city to settle. One of the first was Randy Young. As Rocky told it, Randy was a hard man with no family he knew about. He was also a filthy man who

never bathed, and his teeth had all rotted out. Randy was a pig farmer, and his farm had been on the same site where Karri's house was today. His farm was far away from the town in that time, and he only went to town when he needed food or whiskey. Rocky remembered one summer there had been a run-in with Randy and the local Shoshoni tribe. Just down from the pig farm was a large clearing next to the river where the tribe liked to gather. The Shoshoni became upset when they found the clearing had become polluted by the runoff from the pigs. Also, the smell was overwhelming even though the farm was about a mile away. Unable to do anything about it, the Shoshoni abandoned the site but warned the pig farmer that his lack of respect for the land would bring him nothing but misfortune.

Rocky continued to tell the story of the wretched pig farmer. As the years went on, Pocatello grew larger and the city encroached on the pig farm. Randy become more reclusive and was hardly seen in town. After several months of no contact with him, the local sheriff went to see what had become of Randy. The sheriff found him dead, lying in his bed. He had contracted tuberculosis and died a long agonizing death. Once Randy was gone, the city cleaned up the farm and sold the land at auction. A family bought the land and built their house on the property. They had lived in the home until their children had grown and all moved away. They put the house up for sale, and that is when Karri and her family had arrived.

Karri was attending Pocatello High School during her senior year. She was excited for the fall semester and all of the fun activities planned for the school year. Karri arrived home from school on a warm September afternoon, when she found her older sister Julie looking frightened and standing outside the house.

"What's going on, Julie?" Karri asked concerned for her sister.

"Oh, Karri, I don't know what was going on, but I was starting some laundry when all of a sudden, this horrible smell filled the room," Julie explained, shaking. "I didn't know where the smell was coming from, but then I heard a sound like pigs in a pen. I looked around the house and out the windows, but there was nothing there. I got so scared that I ran outside."

Karri hugged her sister and said, "Don't worry, Julie, I'm here now. Why don't we go into the house and see if we can find out what was causing the smell and noise?"

The two sisters entered the house, but everything inside appeared normal. There was no bad smell or pig sounds. After looking around, Karri reassured her sister that nothing was wrong and whatever it was, it was no longer

Home where the apparition of the pig farmer appeared.

there. Karri was surprised by her sister's reaction because she had never done something like that before.

Days passed, and everything in the house was normal. October came, and fall was in full force. The leaves on the trees were ablaze with reds, yellows and browns. The days slowly became darker and the nights colder. On one particular night, Karri was excited for the annual Black and Blue Bowl, where the two rival high schools played each other in football. Karri realized she had forgotten her sweater when she arrived at the stadium. Since she was not far from home, she decided to stop by quickly and pick it up.

Karri's room was at the rear of the house near the back door. She took her sweater out of the closet and started for the front door when she suddenly heard a strange noise. It started out soft but rapidly grew in volume. It sounded like the grunting of pigs. Karri's first thought was that her brother had come home and was playing a trick on her. She quietly walked to the door, attempting to catch her brother by surprise. As she reached the back door, the grunts and squeals became very loud. She put her ear to the door and her hand on the knob. With a quick thrust, Karri opened the door and jumped outside into the empty backyard. Not a sound could be heard

The room where the pig farmer was seen walking through the wall.

except the wind blowing through the sagebrush and trees. Karri stood dumbfounded. She ran around the sides of the house to see if someone or something was hiding, but she found nothing. Confounded, Karri left for the game, wondering if she had imagined everything.

The weeks passed, but Karri was dismayed by her experience. She didn't tell anyone about what had happened because she didn't want to worry her sister. Halloween was coming up, and she supposed her imagination had gotten the best of her. The days were cold now, and the sun's rays gave little warmth. Karri prepared for winter by piling thick blankets on her bed. The extra blankets kept the cold out and made her feel more secure at night.

One night, Karri had been in a deep sleep when she suddenly found herself half-awake in her room. Something had awoken her, but she couldn't understand what it was because of the haze in her mind. As she began focusing on the real world, she became aware there was an annoying sound in her ears. Suddenly she was wide-awake as a bolt of fear and adrenaline shot through her body. Her heart was pounding a million times a second as her fingers gripped the blankets. The sound of grunting, squealing pigs

filled her head like thousands of needles poking at her. Her eyes adjusted to the darkness as she looked around her room. A pungent stench filled her nostrils as Karri gagged and coughed. Her eyes grew large as she saw a glowing figure walk out of the wall. The apparition was that of a man wearing a straw hat, overalls and long wader boots. He paid little attention to her but had an angry look on his face. He walked across the room as if the house did not exist and disappeared into the opposite wall. As soon as the man disappeared, the grunts and squeals stopped. The horrible stench evaporated, and Karri was left alone in her room.

The next morning, Karri awoke exhausted. She had not slept for more than what seemed like a few minutes. She could not contain herself and confided in Julie about what had happened the night before. They decided to tell their parents, and to their surprise, their parents also confessed having experiences with the ghost pigs. The family gathered later that evening and in a loud voice asked the pig farmer to leave their home. The ghost pigs and farmer never bothered them again. However, their house was built on sacred Shoshoni tribal land, and over the years the family continued to have many strange experiences…but that is another story.

WITNESS PROTECTION

Gary walked into the small stone house and placed his suitcase on the bed. The residence was small with a kitchen, living area, bathroom and bedroom. It was just one of several small houses located on the FBI compound in Pocatello, Idaho. Gary was only passing through, and this was only one stop of many while he was being processed by the witness protection program. Gary had been a high-ranking member in a New Jersey crime family, but when he was arrested on racketeering charges, he had agreed to testify against his boss. Gary questioned whether or not he had made the right choice to go into the program, but it was too late now—he was stuck.

Special Agent Lewis was in charge of Gary and was both guard and protector. He was a large man with a sour disposition. Gary had never seen even a hint of a smile on his face. He always wore the same black suit, white shirt and gray tie. Lewis also wore black wraparound sunglasses, even when it was dark. Gary thought he was just trying to put up a persona. The two men coexisted, but nothing personal was ever shared. Gary had tried to tell Lewis about his life back in New Jersey, but he said it wasn't necessary for him to know that information.

Gary began to settle into the little house, putting his clothing away and placing a picture of his mother on the wall. He didn't know for sure, but he thought his stay would last about a week. After a week, he would be sent somewhere in California with a new identity and was excited to begin a new life. He never had been to California before, but everything he had heard

was good. Gary placed his suitcases in the closet and sat down in the living area to watch TV.

"It's about time for me to go. Is there anything you need before I leave?" Lewis asked as he put his jacket on.

"No, I'm good, but tomorrow can we go to the store?" Gary requested politely. "There are a few things I would like to pick up, and this place seems like a nice little town. Maybe we should check it out?"

"Sure, I'll take you around town tomorrow," Lewis spoke as he walked out the door. "Have a good night, and I will see you in the morning."

Gary spent the rest of the evening eating dinner and watching TV. He watched the late-night news to see what the weather would be like the next day and then got ready for bed. Gary was average height but overweight, and the small house did not always fit him. The bathroom was too small, and there wasn't enough space between the sink and the wall. Gary put on his pajamas and brushed his teeth. When he lay down in bed, he found it was too small, and his feet hung over the end. Feeling very uncomfortable, Gary did his best to fall asleep.

Small house located on the FBI complex.

Gary opened his eyes in the darkness, wondering where he was. It took a moment for his mind to come out of its haze, but he eventually remembered where he was. As he was thinking, he wondered what had woken him up. He lifted his head and looked at the wall. A window allowed the lights from the large FBI office complex to illuminate the room. Gary's eyes began to adjust to the darkness, and he could see that the closet door was open. It had been the squeaky door that had awoken him.

Gary was about to get out of bed to close the closet door when he realized he was not alone. In the corner of the room stood two tiny figures, barely visible in the low light. He struggled to see if they were real or if he was imagining them. Slowly, the figures came into focus. Two young girls in white cotton dresses stared at him as he lay in his bed. Startled, Gary sat up and pulled the covers to his chest. The two girls moved out of the corner toward the foot of the bed. He tried to move but was paralyzed with fear. As the girls stopped in front of him, they slowly lowered themselves until they had disappeared under the bed. Not knowing what to do, Gary sat in his bed for what seemed to be an eternity.

After several hours, Gary found enough courage to jump out of bed and turn on the light. When the light came on, the room was empty. He could see there was no one under the bed or hiding in the closet. Not wanting to stay in the room, he grabbed the covers off the bed and spent the rest of the night on the couch.

Special Agent Lewis arrived in the morning to find Gary a total wreck. He had not slept the entire night and was even more high-strung than normal.

"Agent Lewis, you have to get me out of here," Gary cried as Lewis walked through the door. "I can't spend another night in this madhouse."

"Calm down, Gary," Lewis said in his monotone voice. "First, tell me what happened."

"I went to bed and woke up in the middle of the night." Gary was very animated as he retold his story. "I noticed the closet door was open, and so I start looking around. It was dark, and I had a hard time seeing, but I noticed two little girls standing in the corner. These girls are just staring at me like I'm some kind of jerk. Then they walk over to the bed and crawl under it. I'm so scared I can't move for hours. When I finally turn the light on, the room is empty. I looked everywhere, and those girls are nowhere to be found!"

"Hmm," Lewis grunted as he rubbed his chin with his hand. "I was afraid of this. This hasn't been the first time someone has seen those little girls."

Gary's mouth dropped in astonishment. "What do you mean, not the first time?"

Lewis took off his sunglasses and looked Gary directly in the eye. "I guess you deserve an explanation, but what you have to understand is you don't talk to anyone about this. It's classified. People have been coming through this house for a long time, and some of them have seen those little girls. This house was built in the 1940s when this complex was a naval ordnance plant during World War II. When the FBI complex was built, they kept the houses for training and people like you to stay in. As time when on, people began to report seeing two little girls in white dresses in the bedroom. There were so many reports that the FBI did an investigation, but the findings were inconclusive. I don't know more than what I have told you, but if you want to transfer houses, we can talk to the head administrator and he can tell you more."

Gary cleaned himself up and prepared to go out for the day. Lewis took him to the store so he could buy some supplies, and later in the afternoon, they stopped for a bite to eat. The two men made a very odd pair and seemed to be very uncomfortable having to be around each other. Lewis received a call on his cellphone while they were eating.

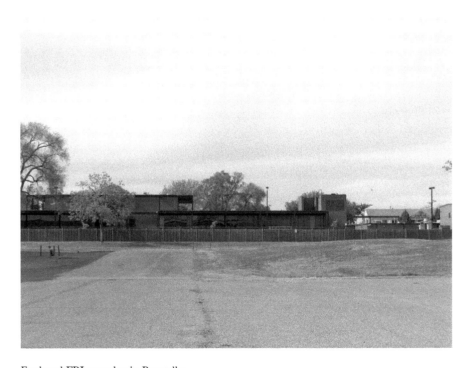

Enclosed FBI complex in Pocatello.

He was only on the phone for a minute when he snapped his phone closed and said, "Let's go, the administrator wants to talk to you about your housing situation."

Gary and Lewis jumped in their vehicle and drove directly back to the FBI complex. Passing through the gates, Lewis immediately drove to the main building. Gary followed Lewis into a large open foyer and down a hallway of offices. At the end to the hall was a medium-sized corner office where a man sat behind a desk.

The man stood up and greeted the two as they walked into the office. "Hello, Special Agent Lewis. How are you doing?"

"I am doing fine, sir," Lewis responded quickly. "May I introduce you to Gary, our special guest in housing unit 12A."

"Very nice to meet you." The man shook Gary's had as he introduced himself. "My name is Special Agent Todd and I am in charge of this facility. I understand that you had a strange experience in the house we provided you?"

Gary was exhausted and had trouble speaking. "Yes, sir, I'm not sure how to describe it, and even when I do, it's hard to believe. I saw two young girls appear to me in the bedroom last night. I know it sounds crazy, and I was half asleep, but I know that it was real."

"I understand, Gary. In fact, I believe you," Special Agent Todd reassured him in a warm, accepting voice. "You are not the only one to have an experience in that house. One of the reasons I wanted to talk to you was so that I could record what happened to you. One of my hobbies is the history of this base and the different people who have gone through here. Over fifty years ago, those houses were built by the navy for the families of the officers in charge of this base. Back then it was a naval ordnance plant, which refurbished guns for battle ships. There is a story about a captain who came with his wife and two young daughters. According to the story, the girls were playing by a truck when the load it was transporting fell off. Both girls were killed, and the captain and his wife were devastated. Many years after the accident, people began to report seeing two young girls in the house where you are staying. The interesting thing to me is the similarities in the stories over the past thirty-five years."

Gary shifted in his chair and looked directly at Todd. "So what you are saying is that I'm not alone in seeing these girls? That makes me feel better because I thought I may be going nuts."

"I'm glad you feel better, and tonight we are going to transfer you to a room here in the main building," Todd responded as he motioned to Lewis

to pay attention. "Tonight will be your last night here. In the morning you will be going to an undisclosed facility in California. I'm sorry about the inconvenience, but I'm sure it's what you want."

"Of course, I don't want to spend another night in that spook house," Gary spouted as he stood up to leave. "I have seen many things in my life, but what I saw last night was the strangest."

Lewis escorted Gary to a room with a cot down the hallway from Todd's office. Exhausted, Gary lay down to take a nap. Even though there was more noise than at the house, Gary felt more assured with people around. The next day, Lewis drove Gary off the base to the airport. As he left, Gary looked back to see if the two young girls were watching from the bedroom window.

CHAPTER 14

I LIKE YOU, AND I'M FEELING
LOVEY, TOO

Bret walked into the aging building without a moment's hesitation. His blue eyes struggled to adjust to the pitch-black room. He had become familiar with the sensation of being in strange, dark places. Bret was an experienced ghost hunter and had been investigating the paranormal for many years. He had formed a paranormal investigative team that started with friends and family but had grown into a well-respected group. It was fun, but the group took its work very seriously. Some members said they experienced strange events and had even seen full-bodied apparitions. Bret never had any personal experiences, but this night would be very different for him.

The team was invited to investigate a reportedly haunted building in the old part of town. It was built at the turn of the century by a family who had come from England. The building started out as a mercantile, then a dairy and finally a warehouse. The edifice was owned by a large family named the Pollards. They owned a few stores around town, and they used the building to store merchandise. It was located on First Street in the oldest part of town. First Street was lined with old decaying structures that gave it a dark, forbidding atmosphere.

The night followed the usual pattern as the group prepared for the investigation. They walked through the two-story building looking for the best locations to place their cameras. The second floor was a large open room with a few smaller rooms on the side. Most of the space had unfinished concrete walls and was being used to store merchandise for the family business. One room, however, was different than the others. The walls

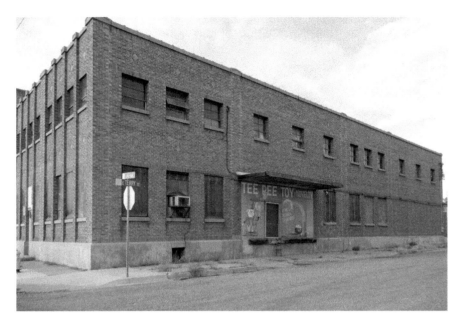

Teepee Toys Warehouse, originally built by a family from England.

had been covered with wood paneling, and the floor had been carpeted. Someone had lived there, leaving what remained of a bed frame in one corner and shelving in another. The room instantly felt different, almost warmer, more inviting, like it had a personality. The Pollards had told stories of strange occurrences in the room. Some family members wouldn't go into it any more, but they wouldn't say why.

The team finished setting up their cameras and returned to the home base on the first floor. The lights were turned off, and the group split into their different crews. Bret was teamed with Ryan, a new investigator on his first ghost hunt. The night started with little excitement. Bret and Ryan explored the back of the building finding nothing but old machinery and an elevator shaft. Time passed quickly, and the teams covered the building with few results. Even though the warehouse had an ominous exterior, the interior felt very pleasant. After a few hours, the teams met back at the base. The decision was made to go out for food and drinks. Bret and Ryan were left behind to watch the equipment.

Alone in the building, Bret and Ryan decided to go to the second floor and investigate. When they arrived, the strange room with wood-paneled walls seemed to draw them in. The pair of investigators stood in silence trying to

comprehend the strange difference they sensed in the room. Bret felt a cold breeze on his cheek. He took out his digital audio recorder and began to ask questions out loud. He hoped to catch an electronic voice phenomenon (EVP). EVPs are when a person uses an audio recorder to capture sounds or voices that cannot be heard at the time of recording.

"Is there anyone here who would like to communicate with us?" Bret called out.

Suddenly, Bret felt a cold sensation on the back of his neck. He continued to investigate professionally without getting too excited. Ryan walked down the center of the main room until the glow of his flashlight was all that could be seen. Bret stood still in the darkness and tried to regain the strange sensation. As the seconds passed, Bret felt like he was not alone, but instead of fear, he felt an overwhelming sense of peace.

Ryan returned from the other end of the building several minutes later. He found Bret calmly sitting on the floor. He approached Bret and sat down beside him.

"It has been a really quiet night," Ryan whispered. "If I had a sleeping bag, I would probably go to sleep."

Bret didn't say anything.

"Hey, are you OK?" Ryan said with a tone of concern.

"I don't know how to explain it, but I think someone is here with us," Bret responded in a low whisper. "It isn't bad or scary. I think it likes us here. That's why we feel so comfortable."

"I don't understand," Ryan answered. "I always thought a spirit would cause someone to feel scared. I know that is why I'm here—I want to see a ghost and run out of here screaming."

"No, that's not why we are here," Bret replied. "If you think about it, we are investigating some of the deepest questions in life. Do we continue after death, or is it the end, like a light bulb going out?"

"I understand, but what's wrong in having a little fun?" Ryan responded.

"There is nothing wrong with having fun, but there is a time and place for everything," Bret explained. "I enjoy being able to come into places the normal public doesn't have access to. I enjoy spending time with the rest of the team. The best part is when we actually capture evidence of something communicating with us."

"What kind of evidence have you caught?" Ryan questioned interestedly.

"I have seen things move by themselves on the DVR. I have heard voices caught on recorders, and I have seen strange objects caught in pictures." Bret listed all of the different types of evidence he could remember.

Second-floor room where EVP saying, "I like you, and I'm feeling lovey, too" was captured.

"That really sounds cool, but have you personally had anything happen?" Ryan asked directly.

"There have been times when I thought I felt something," Bret answered as he pondered the question. "An example would be tonight. I felt there was a presence in the room with us. It didn't touch me or speak to me, but I felt it was there. Now tomorrow, when we get a chance to review the cameras and recorders, we may find evidence that our feelings were correct."

"I hope we catch something, because tonight has been a real letdown for me," Ryan whined.

"I understand, but with time, you will understand that what is on TV is not always how things really are," Bret said. He then stood up, and the pair returned to the home base.

The rest of the night was very calm and quiet. The investigation ended, and the group disbanded into the night. It was close to 3:00 a.m., and Bret was tired when he got home. The next morning, Bret met the other group members to begin the evidence review. In the basement of a member's home, the investigators formed a line of computers as they each reviewed video, photos or audio. The evidence review was always an exciting time as they shared the different anomalies they had captured.

Second floor in Teepee Toys.

John, one of the lead investigators, spoke up in a loud voice. "Hey, I think I have got something here. Bret, what do you remember of when you and Ryan were investigating on the second floor?"

"We were up there alone, but I had a feeling like something was with us," Bret said with a confused look on his face as he recounted the experience.

"The presence was a good one, like it wanted us to be there. I felt so calm, and I even mentioned it to Ryan."

"That is really interesting," John exclaimed excitedly. "Think about what you just said and then listen to this recording."

Bret took the headphones from John and put them on his head. Bret felt his hair stand on end. The cold sensation on the back of his neck returned, and his eyes widened. Bret could hear his conversation with Ryan from the night before. As the recording ended, a woman's voice appeared. She had a British accent and simply said, "I like you, and I'm feeling lovey too."

Bret was shocked and listened to the recording over and over again. The woman's voice was as loud as Ryan or himself, but neither of them had heard it. Ryan listened to the voice intently and was amazed at the simple message she gave. As the two investigators walked out of the house, Ryan pulled Bret to the side.

"I wanted to say that you were right," Ryan rambled excitedly. "You said you felt a presence, and she was there. I am so pumped! Last night was awesome."

Bret smiled and looked Ryan in the eye. "This is what it is all about. Think of how profound this evidence is. We captured a voice communicating with us from the afterlife. Also, this woman was not scary or threatening but kind and inviting. I think we can take comfort in the fact that we have nothing to fear when we pass on to the next life."

Ryan turned as if he was about to walk away but paused to ask one last question. "What do you think she meant when she said, 'I like you, and I'm feeling lovey too'?"

Bret hesitated as he thought of the answer and then responded, "I don't know, but I guess this means I have found my soulmate."

Both men laughed as they turned and walked to their cars.

CHAPTER 15
MAN ON THE CATWALK

Jared operated a large crane inside the old NOP building on the north end of Pocatello. The naval ordnance plant, or NOP complex, was built during World War II to refurbish the big guns for battleships. The building was massive at 840 feet long, 352 feet wide and over seven stories high. The plant's yellow exterior made it unmistakable as people drove down Yellowstone Avenue, the busiest street in town.

The NOP complex had eventually grown to twenty-seven buildings, but after the war, the buildings had been decommissioned. The present day saw a variety of individual manufacturing companies leasing the buildings separately. Jared worked for a company that had leased the main building to make steel beams for construction. His job was running a ceiling crane high above the floor, moving material from one end of the building to the other. Jared enjoyed his job, and it paid well, but an unexpected incident made him question whether he should continue working.

The first time it happened was on a warm sunny morning in May. Jared had been doing some paperwork in the office when he decided to check on another project that was about to start. He walked out on to the main floor and headed toward a group of workers on the far side of the building. About halfway across the floor, Jared heard a noise above his head. He looked up at the catwalk that circled the ceiling and noticed there was a man walking near the crane. The man had dark skin, blue overalls and curly black hair. Jared detected right away that the man was not wearing a hard hat. The use of a hard hat was required for anyone on the main floor and was seen as a

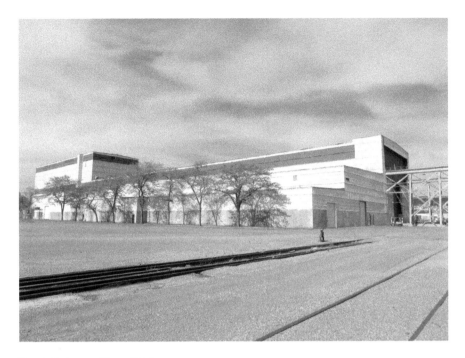

Naval Ordnance Plant, 2013.

major safety violation. Not wanting to risk an injury, Jared quickly started up the catwalk stairs to head off the hazardous situation.

There were several levels of catwalks on the side of the building. Jared hurried up the winding stairs, looking up to see where the man was heading. He finally reached the floor just below the spot where the man was walking. Out of breath, Jared took a few deep gasps and continued the chase.

"What do you think you are doing?" Jared yelled at the stranger one floor above him. "Don't you know hard hats are required in the building?"

The man did not respond or acknowledge Jared and continued walking toward the end of the walkway. Jared was vexed by the apparent snub and quickly climbed the stairs to the next level. As he reached the top of the stairs, Jared searched for the man at the end of the walkway, but he was not there. Jared panned the rest of the floor but quickly saw it was completely empty. Puzzled, he began to think of possible ways the man might have escaped. At one end of the walkway, there was a hatch to the roof, but the hatch was sealed with a lock that required a key. There was also the crane he operated, but it was parked on the opposite end of the building. Dumbfounded, Jared climbed back down to the main floor.

The next day, Jared confided in an old-timer named Tony. Tony had worked at the NOP plant since the seventies and knew just about everything about the history of complex.

"Tony, I have to tell you about something strange going on," Jared said excitedly. "I was walking across the floor, and I swear I saw a man walking across the catwalks. I noticed he didn't have a hard hat on, so I went up there to see what he was doing. I saw him like I see you now, but when I yelled at him he just kept on walking. So, I get all the way to the top, and he's gone. I looked all over for him, but the guy vanished into thin air. Tony, don't tell me I'm crazy, because I know what I saw."

Tony got a large grin on his face and began to chuckle. "I do believe you saw Old Jim. Don't worry, lots of people have seen him; even I have seen him before. Jim is part of the job, and over time you will get used to it."

"Are you saying our building has a ghost?" Jared asked as a skeptical look came across his face.

"Yes, I guess you have never heard the story of Old Jim," Tony said as he sat down in a chair and prepared to tell his story. "Back in the 1940s,

Historical picture of Naval Ordnance Plant. *Courtesy of Idaho Digital Resources, ISU Special Collections.*

the NOP plant refurbished the big guns off of battle ships. After they were done, the guns would be shipped out to the Arco desert to be tested. Today the Idaho National Engineering Laboratory or INEL is what became of the old testing range. Anyway, I don't know exactly when, but during that time a man named Jim worked here in this building. The story says that one day he was walking on the plant floor when an accident happened. One of the big guns came loose and fell to the ground, crushing Jim to death. Back in those days, men didn't always wear protective gear like hard hats, not that it would have helped him. Years later, workers began to report seeing a man walking around in the rafters. By the time I started working here, the other men had started calling him Old Jim. He scares the heck out of the security guards at night and seems to have somewhat of a mean streak in him. Old Jim enjoys scaring guys by popping up out of nowhere and then disappearing into thin air. He can be anywhere in the plant but tends to favor the scaffolding. That's where I saw him plain as day looking down at me from the ceiling. I had the feeling he wished I would get crushed the same as he did."

"That is an amazing story," Jared responded enthusiastically. "I had a feeling that guy was a ghost, but I didn't want people to think I was crazy. Thanks for talking to me, Tony; this thing was starting to get to me. Now that I know I'm not the only one to see Old Jim, I feel better."

"Be careful," Tony cautioned. "I have heard Old Jim can be temperamental, and if he doesn't like you, he will let you know."

Jared felt better after his conversation with Tony, but as time passed, he began to feel uneasy about having to work around a ghost. Weeks went by until one afternoon Jared was working in the crane. He was moving a large steel beam to the loading dock. The crane was suspended from the ceiling and ran on a track forward and backward. There was also a central pivot that allowed the cab and arm to turn in a full circle. Jared was about to turn the cab around when he looked into his review mirror. Jared slammed the emergency brake causing the large metal beam to swing wildly and almost hit the side of the building. Tony, who was the head supervisor, sprinted up the catwalk to see what had happened. When he arrived at the cab, Jared was sitting angrily staring at the wall.

"Jared, are you OK?" Tony panted trying to catch his breath. "What happened? That beam almost put a hole in the wall!"

Jared lifted the door and jumped on to the walkway. "I was turning to drop the beam down onto the dock when I saw a person standing on the back support beam," Jared said, obviously agitated as he continued. "I thought I was going to kill someone, so I slammed on the brake. I felt the weight of

that beam try to rip the crane out of its track; thank goodness it didn't! I don't feel like falling seven stories to my death. When I realized everything was going to be OK with the beam, I looked back in the mirror, and I saw him standing there: Old Jim, with an evil-looking smile on his face. Then he turns around and disappears into the wall. He wanted to cause an accident and kill me in the process."

"Calm down. Everything is alright. The good thing is that no one got hurt." Tony placed his hand on Jared's shoulder. "Let's walk down to the floor. I'm going to have to fill out some paperwork."

"I'm not going to get in trouble for this, am I?" Jared flashed an irate look at Tony.

"No, but I will have to drug test you," Tony explained. "I'm going to send you home with pay until the results are back. Think of it as a few bonus days off."

"Do you see what you caused, you stupid ghost?" Jared yelled as he walked to the stairs. "I hope you're happy and got a big laugh getting me in trouble."

Jared was suspended for three days until his drug test came back clean. Jared returned to work the following Monday. Tony called him to the office when he arrived.

"Jared, I have to put a statement in your file about the accident," Tony said, handing Jared a piece of paper and a pen. "I just wanted to get our story straight before you put it to paper."

"So what you are saying is that you don't want me to write down that a ghost caused the accident," Jared replied smugly.

"I just had you drug tested. I don't want to have to do it again," Tony chuckled. "I just want to make sure we word it properly because upper management will want to review it."

"I understand, but my biggest issue is what if it happens again?" Jared replied in a worried voice. "I can't be having accidents every few weeks. Safety is a big deal around here, and if something goes wrong, it can get someone killed."

"Remember what I told you?" Tony answered firmly. "You have to get used to this place. If it bothers you too much, that is when something bad will happen. Now, you may never see Old Jim again, or he may pop up tomorrow. The important thing is what are you going to do about it? "

Jared finished writing the statement and then returned to work. Tony's words ran through Jared's head all day. He understood Tony was right. It was up to him to make the situation better. For the next few days, Jared thought about what he could do to fix the situation. Over the weekend, he

looked up a few websites on the paranormal. One site gave the advice you should try to take back the space from the entity. It explained that a person should call out the spirit and tell it to leave. Jared decided to follow the advice and try to take back his work area.

The following week, Jared got keys for the building so he could come back at night. It was close to midnight when he entered the empty building. A few small emergency lights illuminated the bottom level, but the higher levels were completely black. Nervously, he walked to the center of the base floor. He held a flashlight in his hand and moved it across the upper floors looking for movement.

"Old Jim, it's not OK for you to be here anymore," Jared started in a low unsure voice. "You need to leave and not come back to this place. You are dead, and it's time for you to go where dead people go."

Jared paused as he listened intently for a response. The building was silent with only a few distant creaks from the settling walls. Jared continued but in a louder and more assertive voice.

"You need to go now. I don't want you to be here anymore. This is my work, and you aren't going to mess it up for me. It wasn't right for you to cause an accident. Just because you got crushed in an accident doesn't mean you should hurt someone else."

Jared could hear rattling on one of the upper walkways. The air began to grow cold, and the darkness seemed to expand as the shadows moved down the walls. Jared knew he needed to be strong in order to will Old Jim to leave. He continued to call out, telling the ghost to leave.

"I said leave now. I command you to get out and never come back," Jared's screams echoed through the building. "This is my building, and I don't want you here."

Suddenly, a low raspy voice spoke next to Jared's ear, "No, you leave."

Jared felt a sharp, burning sensation on his lower back. He placed his hand on the pain and touched a long welt forming just above his hips. Then another pain began on his chest. Jared pulled up his shirt to see a lengthy red scratch. As he pulled his shirt back down, his face began to burn as if a hot needle had been placed on it. Jared began to panic and ran to the door. He jumped into his pickup and sped away. When he arrived home, he found deep scratches on his face, back and chest.

Jared found a new job with a different company. His new job was at the INEL in the Arco desert, and he rode a bus every day to work. The bus route would pass by the NOP complex. Coming home on dark nights, Jared always watched for a dark figure standing on top of the roof.

CHAPTER 16

THE HAUNTED OFFICE

Stephanie was a receptionist at a local construction company. She worked in the company's main office answering phone calls, managing the books and handling payroll. The company's office was located on First Street in Pocatello. First Street was one of the oldest streets in the city and was located directly across from the Union Pacific Railroad yards. The area was affectionately called the "warehouse district" by the locals because the street was lined with large warehouse and factory buildings.

At the turn of the century, this area was bustling with commerce and different types of factories using the railroad to transport goods across the country. Over time, markets changed, causing the businesses to move to other cities and leaving these inordinate shells of their former glory. For years, many of these larger-than-life buildings stood unused. Businessmen began buying some of these buildings for warehouses. The owners once again began using them for local business, bringing a spark of life back to the area. Even with new business, the entire street had a creepy feel about it, especially at night when the dim light from the street lamps would cast ominous shadows cross the gloomy boulevard. Stephanie enjoyed her job but was required to work late some nights. She never liked being alone in the building or having to drive home in the dark; it always gave her the creeps.

Late one night in early fall, Stephanie still had work to finish, and all of the other employees had gone home for the day. She kept an eye on the window as the sun began to set and was hoping to be able to leave before the sun was completely down. She was getting close to finishing her final project

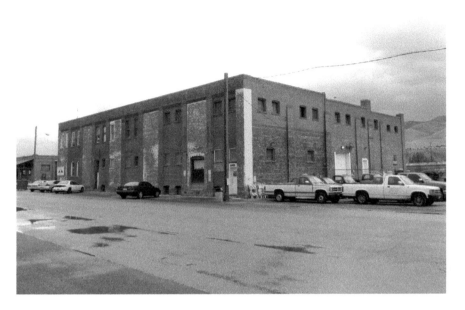

Haunted office building on First Street.

when she heard a strange noise coming from the room next door. She tried to ignore it, but it continued to catch her attention. Finally, she got up and walked to find out what was causing the noise.

Stephanie peeked into the next room with some hesitation. On a desk in the corner sat an adding machine that was spitting out adding paper uncontrollably. Stephanie grabbed the machine, thinking there had been a power surge or some sort of malfunction in the machine. She turned off the power with the on/off switch. The adding machine instantly stopped. Thinking the problem was solved, Stephanie returned to her desk and began to finish her work.

Only a few minutes later, the sound started again. Stephanie stood up, annoyed, and walked to the adding machine. To her wonder, the power was still turned off, but the adding machine was once again printing random numbers on the paper slip. Thinking there must be some type of a glitch in the machine, Stephanie unplugged it from the wall, which caused it to immediately stop. She returned to her desk and started working again. She told herself that she would not get up again until she was done.

Desk where calculator malfunctioned and a little boy played a prank.

Stephanie's heart stopped when the sound of the adding machine reached her ears one more time. It was impossible because she had unplugged the machine from the wall. Reluctantly, she walked to see what was going on in the other room. As she looked around the corner, she saw the adding machine once again randomly printing numbers onto the paper roll. At this point, she was convinced something unseen was playing with her. In her loudest voice, she yelled, "OK, you better stop! If you turn this on one more time, I'm leaving!" As she said those words, the adding machine stopped. Stephanie returned to her desk, praying that the adding machine would not turn back on. With her ear still listening for any sounds, she quietly finished her work. For the rest of the time she was there, the adding machine did not print a single number.

The next day, Stephanie went to see her friend Hannah. "Grandma Hannah," as everyone affectionately called her, was an older lady who had worked in the building since she was sixteen years old. Stephanie told Grandma Hannah about the strange happenings from the night before.

She told Grandma Hannah that she could not find an explanation as to what had happened and asked what she thought of the paranormal. Grandma Hannah smiled and then let out a small laugh. Her glistening eyes focused intensely on Stephanie's face.

"You met our building's permanent resident," Grandma Hannah chuckled. "Don't worry dearie, he's harmless. It is the spirit of a little boy who loves to play pranks on those of us who work here. Sometimes late at night he just likes to come out and let you know he's here."

"What do you mean, a little boy? Do you know who he is?" Stephanie questioned.

"No, I don't know who he is, but I have seen him before," Grandma Hannah continued. "Many years ago when I came to work here, I had an experience with him. I went into the bathroom, and as you know, the bathroom has a door on both sides. As I shut the first door and locked it, the door on the opposite side of the bathroom shut on its own. At first I thought that perhaps the wind had blown the door closed, so I walked over and locked the second door. Then I walked back across the bathroom, but I heard someone knocking on the door I just locked. I called out to let whoever it was on the other side of the door know that the bathroom was occupied. There was no return answer, but the knocking continued. I walked back across the bathroom and opened the door, but there was no one on the other side. Thinking it was a coworker playing a practical joke, I yelled out, 'Very funny!' and I relocked the door. I had just sat down when the toilet paper on the roll began to unwind. The roll was attached to the door and was eye level with the person using the facilities. It was very slow at first, and I did not really notice it until it got faster and faster. Soon the toilet paper began to fly off of the roll across the bathroom. I knew it was not the wind; it looked as if someone was grabbing the sheets and giving them a big pull. It scared me so bad I jumped out of the bathroom and ran for the front door. As I was leaving, I looked back, and that's when I saw him. He was just standing in the bathroom doorway with dirty blond hair and faded clothing. It seemed to me that he was sad to see me go and was sorry to have scared me. As time moved on, I became more accustomed to the idea he was here. I began to talk to him when I was alone. I told him I was OK, and he didn't scare me anymore. Over the years, I have seen him time and time again. Anyone who is in this building for an extended period will run into him or be subject to one of his pranks. He is nothing to be afraid of. Just remember he is a little boy and just wants to play."

"OK, I can see that he is just a child and was just trying to say hello," Stephanie said with relief. "I will let him know that I'm OK if he comes around when I'm here."

"Good, that's the best thing you can do," Grandma Hannah replied. "In fact it's the only thing you can do; he has been here a lot longer than you and I."

Stephanie smiled and returned to her desk. She felt much better after hearing Grandma Hannah's experiences and explanation. She also had a feeling her adventures in the building had just begun.

GIRL IN THE PARK

Sally and Tim were brother and sister. Tim was two years older than his sister and took it upon himself to be her protector. Sally thought Tim was the best big brother ever and would follow him everywhere. The older residents in their neighborhood always commented that you never saw Tim without Sally or Sally without Tim. They were not like most siblings their age. They did not squabble or fight with each other. They loved being together and hated to be apart.

It was a Saturday afternoon in April when Sally and Tim headed out the door of their red brick house. Winters in Idaho seemed to last forever, with snow and cold temperatures lasting far into the spring months. Being children with very little patience for the weather, Sally and Tim sprinted outside to spend the evening in the neighborhood park. The day was barely sixty degrees but warm enough compared to the long winter that was just ending.

Playing in the park was a common practice for all of the neighborhood children. As the weather began to warm, the children stayed outside longer to take advantage of the changing seasons. This practice continued through the summer and into the fall until the cold weather and winter snows once again forced the children to stay indoors. Tim and Sally, like all of the other area children, loved to spend every moment outside running and playing together in the community park.

On one side of the park, there was a large grassy field where the children could run, play tag or invent one of the hundreds of games kids create to

entertain themselves. On the other side of the park was a grey metal swing set with four wide seats. Next to the swings was a slide that was so high off the ground many children would get scared just climbing to the top and would have to climb back down the ladder for fear of falling.

Sally loved the swings most of all and spent many hours contentedly swinging and watching the other children run in the park. She loved the feel of the breeze through her hair as she pumped the swing higher and higher. She always felt happy when she was swinging on the old swing set. She felt a bond to the area that she could not explain. Although Tim did not understand her obsession, he was happy to see Sally so content each day.

Sally and Tim crossed the street to the park. They could hear the other children already at play. Running to catch up with the group, they rushed past the utility shed apparently left open by one of the park caretakers. They glanced at each other with questioning looks as to why the shed was open but quickly forgot as their attention turned to catching up with the rambunctious group of youngsters. Little did they know, this shed would change everything they thought and believed about the park.

The day wore on, and the children began returning to their homes for dinner. Most would return to the park after their meal as long as the weather

Swings in Ammon Park where girl in blue has been seen.

Tool shed on far side of Ammon Park.

stayed warm. It was not long before Sally and Tim found themselves alone swinging back and forth. They had spent many evenings alone in the park, and this one was much like the others in the past. As the two children enjoyed the peaceful evening, they began talking of stories they had heard about the park. They talked of the girl who was said to appear at dusk. She was described as a young girl and always wearing a blue dress. One of the other children told them he had seen the girl late at night swinging on a swing all alone. He thought she looked lonely and that she wanted the children to come back to play with her. Tim did not believe any of the stories and told Sally he believed they were made up by the older boys to scare the younger kids.

As Tim and Sally talked, they began to get a feeling as though they were being watched. Sally told Tim she had a weird feeling that someone was watching them from the bushes. Sally looked over her shoulder, thinking she would see one of the other children returning to the park, but as she looked behind her, no one there. Sally told Tim that she did not want to talk about the girl any more. As the feeling continued, the two children decided to go home.

On their way home, Tim remembered the open shed at the edge of the park. Sally and Tim walked over to the shed and looked inside. The shed

was small, and inside were tools used for park maintenance. It smelled like gasoline from a lawnmower stored in the back of the shed, and lawn clippings lay scattered on the floor.

"Come on, Sally. Let's go inside and check it out," Tim said as he entered in the doorway.

"I don't want to. Can't we just go home?" Sally begged. "It's cold and dark in there. Plus, we could get into trouble if someone catches us in there."

Tim did not hesitate and entered the shed. Not wanting to be left alone, Sally followed behind. As the children reached the back of the shed, the door slammed shut. Suddenly, they were completely submerged in darkness. Tim found his way back to the door but found it was locked tight.

"Tim, get me out of here," Sally cried in the darkness.

"I can't, the door is locked," Tim responded remorsefully. "We have to pound on the door so someone will let us out."

They pushed with all of their strength trying to open the door, but it did not budge. The two children then pounded and yelled trying to alert someone to their predicament, but after an hour, they realized everyone had gone home for the night. The shed began to get cold and Tim and Sally huddled together in the corner trying to stay warm. Tim hoped that someone would notice they were missing and would come to the park looking for them.

After what seemed to be hours, Sally heard a soft scratching sound coming from outside. It started on the side of the shed but slowly moved to the front. Soon, the noise was on the shed door as if someone was outside carving their name into the wood.

Not know what it was, Tim called out to the sound. "Is someone out there? We are locked inside the shed. Could you please help us get out?"

The noise suddenly stopped, and the door popped open. Tim grabbed Sally's hand and quickly pushed the door open. The sky was dark, and the stars where out. The chill of the night stung the children's skin as they walked out onto the grass. Tim quickly looked around for the person who had opened the door, but the park was deserted.

Not being able to see anyone, Tim turned to Sally and asked, "I don't know what happened, but we are out. Are you OK?"

"I'm OK," Sally spoke with a quiet voice. "I know who let us out."

Tim watched as Sally pointed across the park to the old swing set. In the darkness, a small figure wearing a blue dress could be seen rocking back and forth as she glowed in the obscurity. Tim and Sally quickly turned and hurried home. The brother and sister returned to the park often, always looking for the girl in blue.

CHAPTER 18
FUNNY BONES

Rick Brown was a biology teacher at Pocatello High School in 1952. He was a tough but fair teacher, and most students liked him. He taught his course in a hidden classroom on the West side of the auditorium building. Students who had never taken his class always got lost on the first day. The summer was coming to an end, and school was about to begin. Rick arrived at the school to begin preparing his classroom for the new semester. When he arrived, someone was waiting for him.

"Hello, Rick. How was your summer?" Don, the school principal, greeted him.

"Not bad. The family and I spent a lot of time camping and fishing. We mainly stayed in Yellowstone and the Tetons," Rick replied. "You must have a surprise for me to be waiting here like this."

"Indeed I do, my friend." Don gestured to a large wooden crate in the corner of the room. "It is your replacement, all the way from Indonesia."

Ricks face lit up in excitement as he spoke. "You finally got it for me! Help me get it open."

The two men grabbed a crowbar and hammer and began to pull the nailed lid off of the crate. When the lid was off, the first thing Rick saw was a toothy grin. The crate contained the new classroom skeleton. The bleached white bones were wired together and hanging from a hook on the metal stand.

"The kids will love this when I teach anatomy!" Rick expressed his enthusiasm as he placed the skeleton next to his desk. "How did you finally get one?"

Harvey Funny Bones, classroom skeleton.

"It wasn't easy or cheap," Don replied. "I bought him directly from a company in Indonesia that specializes in classroom skeletons. I guess they have to obtain a dead body, get all of the flesh off of it and then prepare the bones. Nasty process, but I suppose that is why they come from Indonesia. I was thinking we should give our new friend a name. Can you think of one?"

Rick thought for a moment and then jokingly said, "How about Harvey Funny Bones?"

The new semester began, and the students were thrilled with Harvey Funny Bones. They joked about his toothy grin and curiously examined his bleached white bones. When it came time to study human anatomy, Harvey was put to good use. Many of his bones were detachable, so Rick was able to remove them and teach the students about the bones' characteristics in detail. Everything was going well until one week before Halloween.

Rick arrived early to grade some papers, but when he walked into the classroom, something was wrong. Three of Harvey's ribs were missing. Rick checked the room, but the ribs were nowhere to be found. When classes started, he asked all of the students to look for the ribs, but no one could find

them. Later in the day, a student named Becky walked into Rick's classroom holding the three ribs in her hand.

"Mr. Brown, I found Harvey's ribs," Becky said, handing the bones to Rick as she spoke.

"Oh Becky, thank you very much. I was worried they were lost for good," Rick responded with a sigh of relief. "Where did you find them?"

"I was in my fifth-hour drama class, and I found them sitting on a table behind the stage," Becky said happily. "I don't know who put them there, but as soon as I saw them I brought them to you. Since I found them, do you think I could have some extra credit?"

"Thank you for bringing them to me," Rick rolled his eyes and responded sarcastically. "I will see what I can do about the extra credit. I will have to start locking Harvey up because it sounds like students are removing things from my classroom."

That night, Rick began to lock Harvey in a closet in the back of the room. He kept a close eye on the students during class so no one could walk out with one of Harvey's parts. Everything was fine until a few days

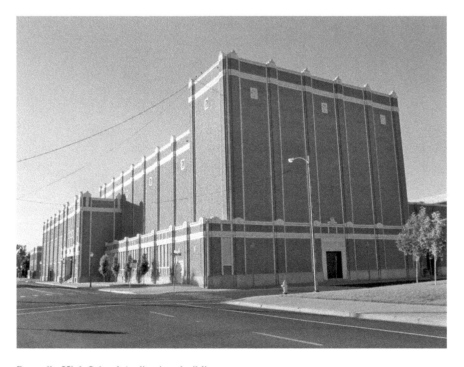

Pocatello High School Auditorium building.

107

before Thanksgiving. Rick was giving an exam to his first-hour class when the janitor came and stood in his doorway. The janitor motioned for him to come out into the hallway. Rick hesitantly rose from his chair and walked into the hall.

"What can I do for you?" Rick asked in a perturbed voice.

"I was sweeping on the back side of the stage and found this sitting on a table." The janitor then handed Rick a skeleton's foot. "I thought it might belong to you since you teach biology."

Rick grabbed the foot with a bewildered look on his face. He quickly walked into the classroom and opened the locked closet where he kept Harvey. When the door opened, he was amazed to see Harvey was missing his left foot. Rick quickly reattached it and returned to the hallway to question the janitor.

"Are you sure you found this on the back of the stage?" Rick questioned.

"Of course. Why would I make something like that up?" The janitor responded defensively. "You should keep better track of your skeleton. You're lucky I found it because someone could have walked off with it."

"I'm sorry. I didn't mean to snap at you," Rick apologized. "I'm the only one with a key to the closet where the skeleton is kept, so I don't understand how it got out. Thank you for bringing it back to me. Please do me a favor and keep an eye out for anyone walking around with skeleton bones."

Rick was baffled by who could have gotten into the closet and taken Harvey's foot. Rick thought of everyone who had access to the closet. Maybe a student took the foot, and he hadn't noticed? Maybe a janitor had a key to the closet, and he didn't know about it? Maybe Don or another faculty member was playing a joke on him? Whatever the reason, Rick was going to put a stop to it. He began to place a piece of tape between the door and wall every night so he could see if it had been opened. His plan worked for many months without a single incident.

Spring was in the air, and the students began to prepare for final exams. Rick was looking forward to his own summer vacation in the mountains and the end of the school year. Just before his first class began, Rick walked to the closet to pull Harvey out for the day. He checked the tape to make sure it had not been disturbed and upon a flawless inspection pulled it off before opening the door. The door swung open, and to his astonishment, Harvey's right arm was missing. Rick stood dazed as he viewed the incomplete skeleton. He quickly reexamined the tape he had placed on the door the night before, but there was nothing unusual about it. Suddenly, he had an idea and rushed out of his classroom. He hurried down the stairs onto the main floor and burst

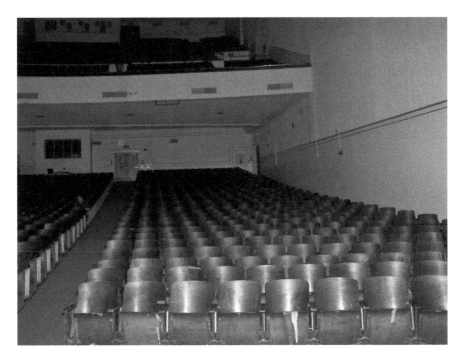

Pocatello High School Auditorium.

through the doors into the auditorium. The massive room echoed as he ran to the dimly lit stage. Rick jumped up onto the stage and ran to a small prop room on the back wall. The skeleton arm was sitting on a table as had been described the last two times bones had gone missing. Rick picked up the arm and returned to his room before class started.

That evening, Rick sat alone in his classroom wondering how the skeleton bones were getting out of the closet. None of his previous theories were plausible. Then a crazy thought came into Rick's mind: maybe the bones were getting out by themselves. Rick stood up and walked up to Harvey and stared into his empty eye sockets.

"OK, Mr. Harvey Funny Bones, if it is you getting out of the closet, prove it to me," Rick challenged the grinning skeleton. "By the end of the school year, I dare you to get out one more time."

With that said, Rick proceeded to lock Harvey in the closet. He also put multiple pieces of tape up and down the doorframe to make sure no one could trick him. In the following days, Rick did not open the closet, not wanting to disturb the tape. The door was completely undisturbed when

the last day of school arrived. After his last class had finished, Rick carefully removed the tape from the door. He unlocked the door with the key and turned the knob. As the door swung open, Harvey's toothy grin was missing: there was only a headless skeleton suspended from the hook. Rick nearly fell over from the shock.

Immediately, Rick headed for the prop room on the stage. When he arrived in the auditorium, he noticed the door on the prop room was open. He walked down the sloping aisle and jumped up onto the stage. A knot grew in Rick's stomach as he approached the door. He quickly walked through the open door and turned toward the table. Harvey's toothy grin hit him with a sobering reality as Rick stared at the skull lying on the table.

"OK, you win, I'm a believer," Rick spoke in a dejected tone. "Let's make a deal. I promise to come and get whatever piece of you appears here on the table, if you promise to only leave when you need to."

Harvey remained silent. Rick picked up the skull and returned it to the closet. Rick continued to teach at Pocatello High School for many years, and parts of Harvey would come up missing from time to time. Rick always knew where to look to recover the missing pieces. In the 1980s, real human skeletons were banned from classroom use and were replaced with synthetic replicas. Today Harvey remains in a backroom closet in the auditorium building at Pocatello High School.

ABOUT THE AUTHOR

Photo by Lisa Brian.

John Brian was born and raised in Pocatello, Idaho. He attended Pocatello High School and Idaho State University. During college, he participated in an exchange program with La Universidad de Guadalajara in Guadalajara, Jalisco, Mexico. While in Mexico, John worked as an anthropologist in the states of Jalisco, Colima, Michoacán, Nayarit, Oaxaca and Chiapas. He also has traveled throughout Central and South America working on different projects. John graduated with BAs in anthropology and Spanish.

When John returned home to Pocatello, he began a career in retail management. Not wanting to abandon anthropology completely, he began to do paranormal investigations. With the help of friends and family, John formed **SPIRO** Paranormal. **SPIRO** is a paranormal investigative team based in the social sciences. John realized American culture had many of the same belief patterns as those he had seen in the traditional people of Latin America. The group's focus is more on people than reported hauntings.

In 2009, **SPIRO** teamed up with Stephanie Palagi at Old Town Pocatello, Inc., to present the Haunted History Tour. The tour is presented every

October and features the history and haunted stories of buildings in Pocatello. The tours have become very successful and are a fundraiser for Old Town Pocatello, Inc.

John and Lisa Brian have four children: John David, Ellie, Megan and Brisa. They plan to continue investigating the paranormal and preserving this unique area of American history. The majority of pictures included in this book were taken by Lisa Brian.

The members of SPIRO include Bret Yost, Lisa Brian, Becky Green, Eric Aldridge, Hanna Holman, Allison Honeycutt, Marlene Murray, Theo Rawson, Geoff Young, Terry Droghei, JM Droghei, Stacey Pearson, Tammy Scardino and Stephanie Palagi.

Also, special thanks to Ian Fennell at the *Idaho State Journal*, Karen and Doug Eby, Golden and Sandy Millward, the Pollard Family, Amerigo Inc., our entire Brian-Robles Family and everyone who has supported the Haunted History Tour.